Acrylics

CREATIVE TECHNIQUES

Designed and produced by Parramón Ediciones, S.A.
Editorial Director: María Fernanda Canal
Assistant Editor: Mª Carmen Ramos
Text: Josep Asunción and Gemma Guasch
Exercises: Josep Asunción and Gemma Guasch
Final Editing and Writing: María Fernanda Canal,
Roser Pérez
Series Design: Toni Inglés
Photography: Estudi Nos & Soto, Creart
Layout: Toni Inglés
Production Director: Rafael Marfil
Production: Manel Sánchez

English translation by Michael Brunelle,
Beatriz Cortabarria, and Jone Brunelle

First edition for the United States, its territories and dependencies, and Canada published in 2011 by Barron's Educational Series, Inc.

English edition © copyright 2011 by Barron's Educational Series, Inc.

Original title of Spanish book: Acrílico creativo

© Copyright Parramón ediciones, S.A., 2009 World Rights
Published by Parramón Ediciones, S.A., Barcelona, Spain

All inquiries should be addressed to:
Barron's Educational Series, Inc.
250 Wireless Boulevard
Hauppauge, New York 11788
www.barronseduc.com

ISBN: 978-0-7641-6390-6

Library of Congress Control Number: 2010041273

Printed in Spain

9 8 7 6 5 4 3 2 1

Acrylics

BARRON'S

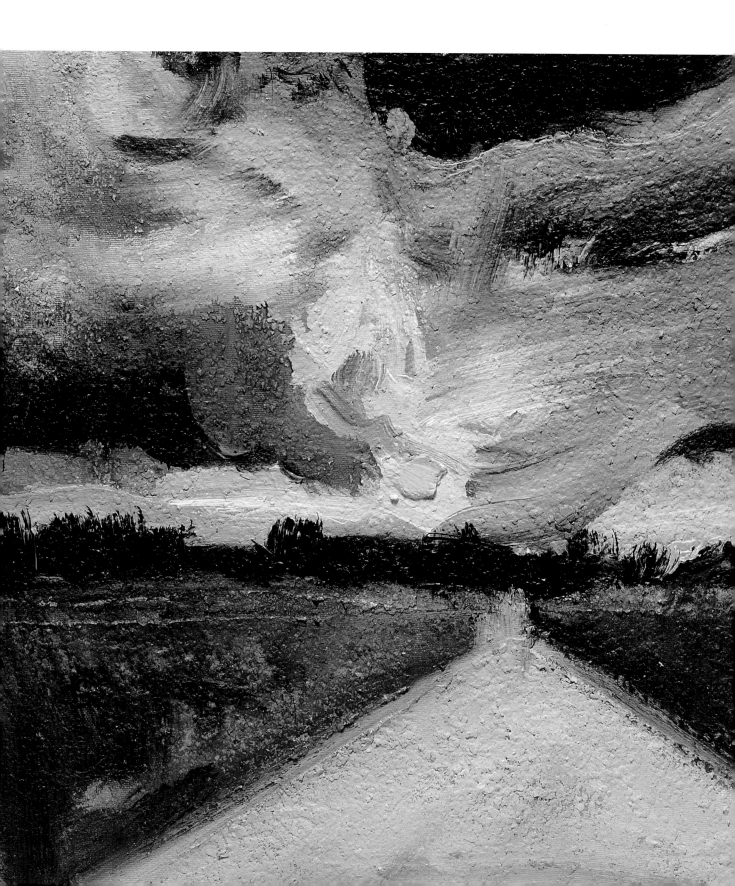

Contents

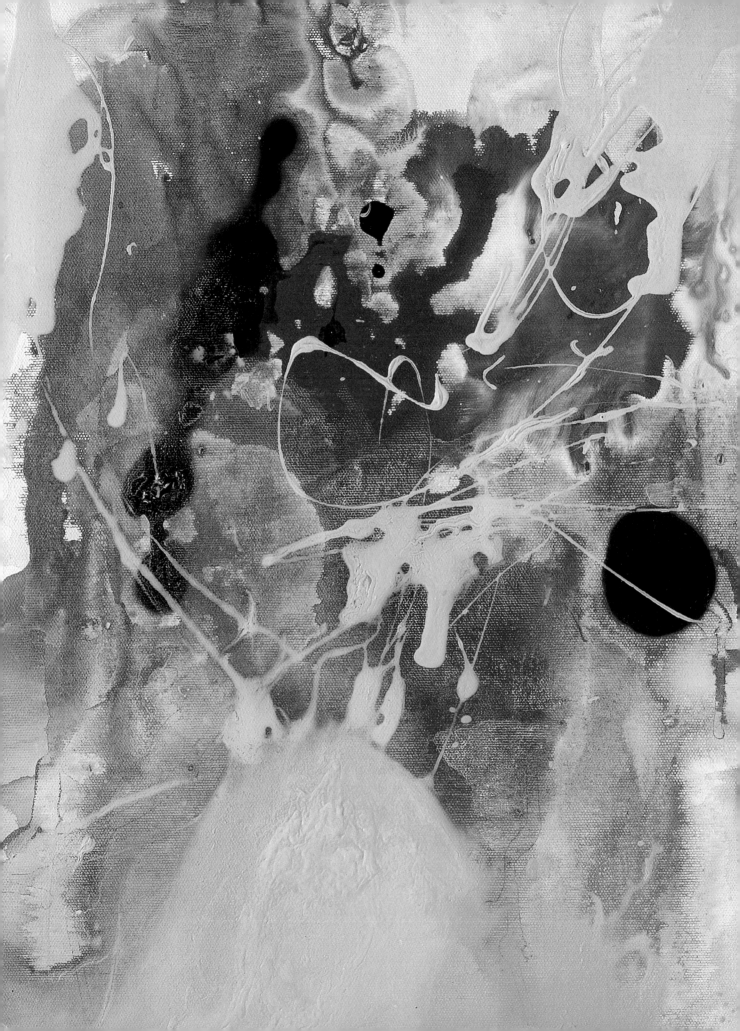

Both are artists and professors of painting in the Escuela de Artes y Oficios de la Diputación de Barcelona. As creative people, they work in contemporary painting and also in new artistic languages like action art, video art, and photography. They have exhibited their work in several Spanish and European cities. Their long teaching experience, in addition to their research and artistic creation are the basis for the contents of this book. Gemma Guasch and Josep Asunción are also authors of the books *Form, Color, Space,* and *Line* in the "Creative Painting" series published by Parramón Ediciones (translations available from Barron's Educational Series, Inc), which has won international acclaim from readers who are increasingly interested in painting as a vehicle for developing their creativity.

Introduction

Acrylics are a relatively new medium. Although they were developed for industrial purposes, they immediately found their role in artistic expression. The first acrylics paints date from the 1940s, when they were used for painting murals in Mexico and the United States. But it was after 1950 that acrylics for artists appeared on the market and became accepted as a legitimate medium that met the technical requirements of the painting styles that were then appearing on the scene: Action Painting, Pop Art, Minimalism, Neo-Expressionism, Street Art, and so on.

Acrylics are the most versatile of the artistic media. They are considered to be truly "all terrain" and are greatly respected. They are easy to use, clean, and economical. They can create finishes that are nearly identical to oils and watercolors, and they offer the opportunity for endless experimentation.

This experimental character is a result of their basic composition: pigment and a water-soluble polymer agglutinate. The polymer industry is in constant evolution. The new substances that appear are immediately applied to artistic use, and the results are truly surprising. On the other hand, the pigments used for color ensure the stability and the brightness of the colors, just like those of oil paints and watercolors.

Their simple composition allows the painter to manufacture his or her own acrylics if desired, and adjust the paint according to his or her needs, since vinyl mediums and agglutinates are commercially available in many finishes when it comes to gloss, texture, and drying time.

Acrylics naturally dry quite fast and hard. This speed is the only complaint that some users voice, but there are slow-drying acrylics and retardant mediums. Because they are polymers, they posses a certain elasticity, and despite their hardness, they do not crack like oils do. They are diluted with water, so they do not have a strong odor, and they are cleaner than other media. However, once the paint has dried, it is very difficult to remove.

Today it is a fast-growing medium and very contemporary. It even allows the introduction of other media, whether wet like ink, watercolor, and oils, or dry like charcoal, pastels, wax, and pencils. This makes acrylics the standard base for mixed media work.

Paint

FORMS

There are many brands of acrylics available on the market today. They are available in two different forms, in tubes or in containers. The tubes come in two or three different sizes, similar to oil paints. The containers vary greatly in size, depending on the brand. There are two levels of quality for the paint, one for artists and one for students. The latter is more economical but has the disadvantage of containing less pigment that is of a lower quality, which causes the color to be less intense. Acrylic paint dries rapidly so you must be sure to close the containers well after each painting session.

Density

Acrylic paint usually has a creamy or pasty consistency. Nowadays acrylics come in other densities, liquid and even fluid like ink. These have a more concentrated level of high-quality pigments, the color spreads better, and it loses neither strength nor brightness. This type of paint tints gels, mediums, gesso, and backgrounds better and more easily. Their difference is that liquid acrylics dry quickly, and their color does not change because they contain pure pigment.

Drying

Acrylic paint dries quickly, creating a strong, hard, insoluble, elastic, and unchangeable film. If you wish to adjust the drying time, you can add retardant medium. The manufacturer Golden sells a product called Open Acrylics, which comes in a tube with incorporated retarder that slows the drying time.

Palettes

The palettes used for acrylics should not be porous, and glass or plastic is preferred over wood. There are palettes sold specifically for acrylics, for example the Staywet palette, designed to retain moisture and keep the paint from drying. Another, more homemade, way of keeping acrylics from drying is to occasionally spray them with water.

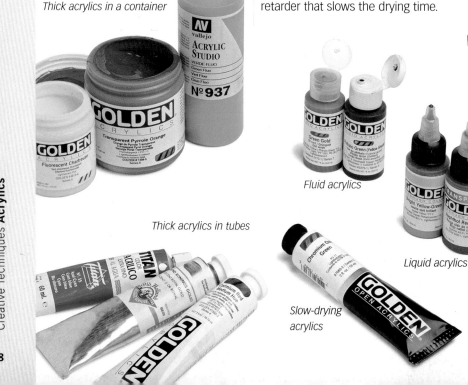

Thick acrylics in a container

Thick acrylics in tubes

Fluid acrylics

Liquid acrylics

Slow-drying acrylics

Special colors:
A. *Fluorescent yellow*
B. *Fluorescent orange*
C. *Iridescent silver*
D. *Iridescent pearl*
E. *Iridescent copper*
F. *Interference orange*
G. *Interference blue*

Acrylic paint is a derivative of the plastics industry, employing the same pigments as oil paint and watercolors, but diluted in a polymer resin. It is a versatile and comfortable medium. It is diluted with water or acrylic medium, and it dries quickly. It is stable, resistant, and uniform. It has a matte finish, but it can be glossy if acrylic medium is added. After it has dried it becomes a plastic film, and it is impossible to remove, which allows more paint to be added or other techniques to be applied.

OPACITY

Acrylic paint can be opaque or transparent, according to the pigment used in its manufacture. Painting with opaque colors will completely cover a previous layer of paint, even if the color underneath is darker. Conversely, transparent acrylic paint, when dry, becomes translucent and allows shades of the colors underneath to show through. Notice the amount of opacity of the basic palette on this page. The colors were painted over a black line so you can clearly see the amount of opacity of each color.

BASIC PALETTE

It is not necessary to have a large number of colors when painting with acrylics, but it is important to have a few colors from each range to have a basic palette so you can begin working.
 It should include:

• Titanium white and ivory black.
• A few bright and luminous colors, like cadmium lemon yellow, magenta, cadmium red medium, quinacridone red, and cyan blue.
• Some earth tones like ochre, raw sienna, burnt sienna, burnt umber, and, finally, raw umber.
• It is also important to have dark colors: ultramarine blue, phthalo blue, alizarin crimson, phthalo green, Payne's gray, and dioxazine purple.

SPECIAL COLORS

In addition to the wide range of traditional colors on the market, there are some special colors, among them the iridescent, fluorescent, phosphorescent, and interference colors. There are also colors that vary in luminosity, whose tones change according to the amount of light they receive.

Iridescent Colors
These can be metallic or pearl colors, and they can be used alone or mixed with other colors, gels, and mediums. The pearl color, mixed with other colors, creates a pearlescent finish.

Interference Colors
These colors change according to the angle from which they are viewed. The color changes and reflects its complementary color based on the amount of light they receive, so interference orange reflects a blue color. This effect is heightened on a black background.

Luminescent Colors
These are very bright and intense colors. They are made with dyes mixed with a polymer coating. The fluorescent pigments are transparent and their effect is doubled on white and luminous backgrounds. The phosphorescent colors glow in the dark.

Basic color palette:
1. *Titanium white*
2. *Cadmium lemon yellow*
3. *Raw sienna*
4. *Light cadmium red*
5. *Magenta*
6. *Alizarin crimson*
7. *Dioxizine purple*
8. *Cyan blue*
9. *Dark ultramarine blue*
10. *Phthalo green*
11. *Permanent sap green*
12. *Raw umber*
13. *Burnt umber*
14. *Payne's gray*
15. *Ivory black*

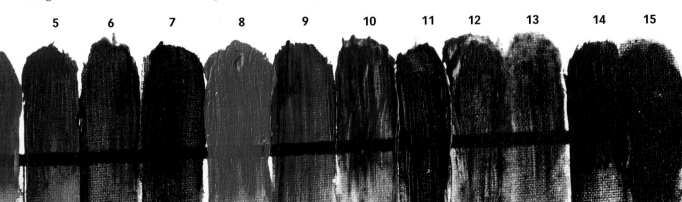

Supports and Applicators

SUPPORTS

It is possible to paint on any surface with acrylics: canvas, wood, paper, cardboard, plastics, and metals. It is a good idea to apply a primer before painting.

Canvas
Acrylic paint gives excellent results on any canvas from the finest linen to the roughest sackcloth. They can usually be purchased already primed from art supply stores. But if you prefer you can buy cotton or linen fabric and prime it with gesso or medium for backgrounds.

1. *Primed cotton fabric*
2. *Primed sackcloth*
3. *Primed fine cotton fabric*
4. *Wood with latex primer*
5. *Pressed cardboard*
6. *Paper with a canvas texture*
7. *Fabric with a relief surface*
8. *Fabric with sand filler*
9. *Fabric with a pumice stone filler*

Wood
This is a good support for painting with acrylics, whether natural wood or plywood or fiberboards. It should be primed with gesso or with a transparent glue that does not cover its natural color.

Paper and Cardboard
Paper is an excellent support because it does not require priming and the acrylic paint will adhere to it very well. Heavy paper and paper with a canvas texture are best for thicker paint. Cardboard can also be used, but since it is very porous you should prime it first with gesso or medium.

Special Supports
Metal and plastic have smooth, shiny, and nonporous surfaces that make it difficult for the paint to adhere. These supports should first be prepared with a medium so you can paint on them with acrylics. There are special products sold by different companies, like the acrylic base for pastels and the GAC 200 (an acrylic polymer that increases film hardness), both made by Golden.

Acrylic paint does not adhere well to a greasy or waxy surface.

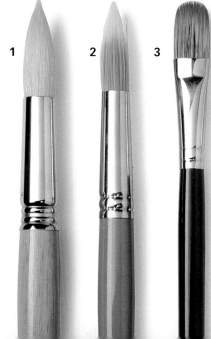

A crylic paint adheres so well that it can be applied to any support that is not excessively polished, repellent, or greasy. Cardboard, wood, canvas, plastic, metal, or any recycled material can be used as a support. The same is true for applicators, most of them will work, but synthetic brushes are recommended.

BRUSHES

Brushes are the ideal applicators for painting with acrylics. Their quality is determined by their components.

Components

A brush consists of three parts, the handle, the ferrule, and the hair.

• Handle. Its quality is determined by the wood used and its lacquered or varnished finish. They are also made of acrylic or plastic.

• Ferrule. This is the part of the brush that holds the hair or bristles to the handle. The best ferrules are chromed, because they will not rust, but they are also made of aluminum and copper.

• Hair. This can be natural or synthetic. The brushes with bristles are ideal for working with acrylics as if they were oils, thick or impasto. On the other hand, it is better to use synthetic brushes for painting flat or watery strokes.

Shapes and Numbering

The most common shapes are round, flat, and filbert. The round brush holds water and paint better. It is important not to allow the tip to become deformed so you can draw fine lines as well as expressive strokes. The flat brushes hold less water and paint, but they are ideal for flat strokes, for covering large areas, and painting impastos and thick paint.

The numbers are printed on the handle and indicate the size of the brush. Generally the lower numbers correspond to fine brushes and the higher numbers to the wider ones.

Care and Maintenance

The brushes used for painting with acrylics should be kept damp while painting. If the paint dries in the hair it cannot be removed. After the painting session is over, they must be washed with warm water and soap.

OTHER APPLICATORS

Wide Brushes

The form of these brushes is flatter and wider than normal brushes, and their handles are flat and wide. They come in different sizes. They are ideal for large-scale work, for covering large areas, and for painting wide strokes. They have either synthetic bristles, which are soft and elastic, or natural bristles, which are stiff and rough.

Spatulas

These are the ideal applicators for painting impastos and creating textures. They are shaped like a deformed knife, with a flexible stainless steel blade and a varnished wood handle. They are also used for scraping, sgraffito, mixing paint on the palette, and retrieving paint from the container.

1. Round bristle brush
2. Round brush with fine synthetic hair
3. Synthetic filbert brush
4. Synthetic flat brush
5. Synthetic wide brush
6. Fan brush
7. Sponge applicator
8. Spatula with a round blade
9. Spatula with a long knife blade

4 5 6 7 8 9

Mediums

AGGLUTINATES

The function of the agglutinate is to bind the pigment and adhere it to the support. Vinyl adhesives and acrylic emulsions fulfill this role in acrylic paints.

Adhesive
Polyvinyl acetate, commonly called synthetic latex, is the agglutinate in acrylic paint. It can be used as a primer if thinned with water, and when it dries it becomes transparent. Glossy and matte versions are sold in plastic containers.

BASES

The bases are the surfaces of a support that has been prepared for painting.

Gesso
This is the ideal base for many painting media. It has equal amounts of vinyl adhesive and pigment (black or white), and it is thick enough to seal the porosity of the support while adding body to the primer coat.

Acrylic Base for Pastels
This base is used to prepare canvas for use with drawing media like pastels and pencils. Before it is applied, it can be colored with any acrylic paint.

Absorbent Base
This liquid medium can be white or transparent, and when it dries it creates a porous surface similar to that of watercolor paper. If it is applied over a canvas that has been primed with gesso, paint applied to it will cause effects reminiscent of watercolors.

Polymer Acrylic for Hardening Canvas (GAC 400)
When this base dries it makes the canvas very hard. It is usually applied to lightweight fabrics like cotton or linen.

Bases, Adhesives, and Solvents
Latex, synthetic adhesive for fabrics (GAC 400), revitalizing solvent medium (open thinner), acrylic base for pastels, absorbent background, and black gasso.

Finishes
Finish varnish in aerosol, final varnish liquid, and UV protection gel.

Textures
Regular gel, gel with fine pumice stone, gel with coarse pumice, and crackle paste.

There are many substances that can be mixed with acrylic paint to modify its fluidity, create special effects, and change the look of its finish. These substances are called "mediums." They are colorless agglutinates that can be used to control and modify the transparency, viscosity, and the finish of the surface.

MEDIUMS

These are acrylic emulsions that cause different effects in the finish, texture, density, and drying.

Finishes

Acrylic paints have a matte finish, but there are many products that can modify them: the mediums, which are mixed with the paint as it is used, and the varnishes, which are applied after the paint has dried.

• Matte Medium. This extends the paint well, reduces its gloss, and increases the matte effect. It is also useful as an alternative to gesso for creating a transparent primer.

• Polymer Gloss Medium. This is ideal for extending paint, and increasing gloss and translucence. It creates a look similar to that of oil paint.

• Varnish with UV Protection. This water-based varnish contains stabilizers for ultraviolet light. It resists the effects of dust and light. It is available in matte, glossy, and satin finishes.

Texture

Mediums used for adding texture range from liquid to moldable, in different grades of gloss and transparency. They can be used alone or mixed with paint. They should not be diluted.

• Gel. This acrylic resin is the same as that used as agglutinate in paint. There are a large number of gels with different densities and finishes. Gel can be used alone or mixed with paint to increase its volume.

• Modeling Pastes. These are thicker than gels. They are quite still and can be used to create paintings with a lot of texture. They can be light or heavy. The lighter ones are best for large format paintings.

• Fillers. These are gels that already have fillers added for texture, like pumice stone of different weights, mica, granite, and fiberglass.

• Crackle Paste. This product is white and looks like plaster. It can be applied alone or mixed with acrylic paint. When it dries cracks and crackling will appear in its surface.

Density and Drying

Gloss gel medium, flow enhancer, clear gel, self-leveling medium, and acrylic retarder.

Density

The following mediums, lighter and more variable, modify the density of the paint.

• Universal Acrylic Polymer (GAC 100). This is very useful for extending paint and increasing the flexibility of the film. It can also be used for diluting the paint.

• Clear Tar Gel. This resin-like transparent gel creates a unique stringy texture. It is ideal for creating dripping and drizzling effects and detailed lines and for pouring over surfaces.

• Self-Leveling Clear Gel. This is a thin and transparent liquid gel that produces an even film of paint. Its final finish is similar to enamel, smooth and even.

Dryers

The following mediums are additives used for controlling the drying properties of paint, but they do not modify any other aspect. They are not agglutinates.

• Retarders. These useful additives increase the amount of time the paint stays fresh on the palette and on the canvas.

• Revitalizing Solvent Medium. This product softens acrylic paint that has already dried. It is useful for recovering paint dried on the palette and for removing unwanted marks.

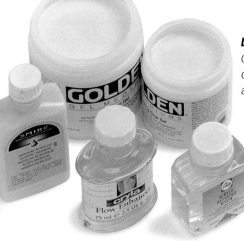

Basic Techniques

PREPARING BACKGROUNDS

Priming Porous Supports

Because the medium is free of acids, acrylics can be used directly on porous supports without risk of the work deteriorating later. The paint is simply absorbed more quickly, but the first applications of the paint itself will cover the pores of the support and act as a primer. For extremely porous supports, like most raw fabrics, there are several options. Special acrylic emulsions, similar to rabbit skin glue, will cover the pores and also stiffen the fabric; there are also matte and liquid acrylic mediums. An atomizer or even a wide brush can be used to apply these materials. It is preferable to apply several thin coats with parallel brushstrokes, changing the direction of the strokes with each successive layer to create uniformity.

If you desire denser primers, like gel, gesso (black or white), or an absorbent acrylic base, they can all be applied with a wide brush.

Impresso primer.

Priming Glossy Supports

Special polymer preparations, like transparent or white acrylic base for pastel, must be applied when working on recycled oil paintings, polished metals, and glossy papers and cardboards. These should be applied using the same technique as that for a porous support.

Creating Painted Bases

In addition to being able to create colored bases by simply adding paint or pigment to the primer, you can create very expressive effects by playing with the thickness or with transferred images. The best way to prepare a relief on a base is to use gel, with or without pigment, because it is elastic and will not crack.

Base made with matte modeling paste slightly colored with yellow acrylic.

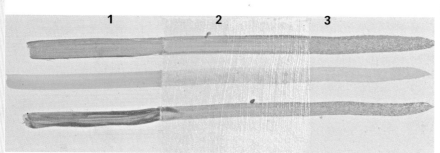

The same brushstrokes react differently to a paper base with different primers:
1. The paint is more intense and opaque on an absorbent white acrylic base. They effect is very similar on gesso.

2. The stroke is more fluid and viscous on a transparent gel preparation, and the color is strong and bright, but transparent.
3. On unprimed paper, the color is duller and has a matte finish.

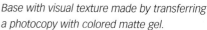

Base with visual texture made by transferring a photocopy with colored matte gel.

crylics are the ideal medium for creative experimentation because they can be used for all the techniques typical of other media like watercolor and oils, in addition to those specific to acrylics. These are based first on the paint itself, its variations of density, gloss, and drying time; and, second, on the way that the color is applied: glazes, impastos, washes, transfers, reserves, and a great number of techniques that are continually evolving.

MAKING PAINT

Coloring with Pigments

Latex is usually used as the agglutinate when making paint with pigments, although a gel or fluid acrylic can also be used. You will need pigment, water, the agglutinate, and a transparent bottle for making the mixture (1). Fill the bottle with pigment and water and shake it until the mixture is smooth and without lumps (2). Allow it to rest until the pigment precipitates in the bottom of the bottle and can be clearly distinguished from the water (3). Next, remove the excess water (4) leaving just the amount that has been absorbed by the pigment, and mix the damp pigment with the agglutinate (5) to create an emulsion (6).

The proportion of pigment to agglutinate affects the opacity and gloss of the paint. Since each pigment is different, it is a good idea to make small experiments and continue adding binder or pigment after checking the opacity and brightness of the paint when it dries. With latex, the final finish should be neither very matte (excessive pigment) nor too glossy (too much agglutinate). You can adjust the proportions with gel or acrylic medium until you achieve the desired effect.

Colors with Liquid and Fluid Acrylics

Instead of using pigments you can resort to using paint with very strong colors, whether liquids (used for airbrushing) or fluids. These are very refined pigments emulsified with vinyl resin. If you desire a viscous effect similar to synthetic enamels, you can use a slightly thicker fluid medium as the agglutinate, like the self-leveling or clear tar gel. When the paint is dry, it will be smoother and more uniform than

that from a tube or a gel. On the other hand, to make a thick paint, denser and with more volume, you can add color to a matte of glossy gel, either heavy or light according to the thickness and gloss you desire.

A preparation of fluid acrylic paint using transparent clear tar gel and liquid acrylic.

A preparation of thick paint with a regular gloss gel and acrylic liquid.

A paint mixture made with pigment and latex.

Basic Techniques

TO LIGHTEN AND DARKEN COLORS

To Lighten Color

There are two ways to lighten an acrylic color: dilute it or mix it with white paint. If you choose to dilute the color, you should work on a white background, as if it were a watercolor. In this case, using water will make the color very transparent, matte, and without body, like a watercolor. But if you use an acrylic medium, you can control the gloss and the body of the paint. Another less common option is to dilute the paint with a gel, which will create a surprising effect similar to that of a watercolor, but with volume. When you mix white with a color, it becomes chalky, gaining light but losing tone. It is best to take advantage of the natural light of each color, adding white only in the areas of the painting that are most brightly lit. Some colors are not very opaque, and they will darken when painted over

others. To avoid this you can mix them with a little white or perhaps add an intermediate layer of white to the painting. Yellow is very bright, but when it is painted over other colors, it loses its light and vividness because it is so transparent (1). There are two ways to avoid this: you can add a little white, or you can first cover the area that will be yellow with white paint (2).

To Darken Color

The two ways to darken a color are to mix it with its complementary color or with black. It is nearly impossible to create absolute black with the complementary color, so you can also add a little black paint to achieve those last dark values. If you choose to always darken with black, you might cause a muddy and even chalky effect while losing many shades of gray that can be very expressive.

Grisaille and Dark Tones

If you wish to paint with very dark colors without using black, you can use colors directly from your palette that are already dark, yet not any less pure, like dark violet, carmine, Prussian blue, sap green, and burnt umber. Mixed with each other they will create an original range of grays that are very useful for very dark areas of a painting.

The grisaille technique consists of creating images with values, based on chiaroscuro techniques. A grisaille barely has color, and it can even be black and white. A good option is to create your own black with very dark colors from the palette and then use it to make grays with the addition of white.

1

2

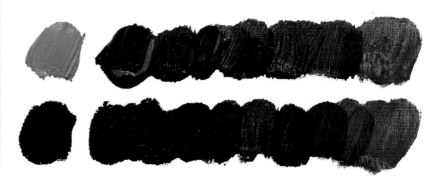

Grisaille in sap green and alizarin crimson.

Grisaille in burnt umber and dark violet.

A color darkened with black has a monotonous evolution toward black. But if it is darkened with its complementary color, it evolves with a series of richer shades of color.

VARYING THE AMOUNT OF PAINT

Modifying the amount of paint is one of the key techniques of acrylic painting. It is a good idea to experiment with different densities.

Diluted Paint
When acrylic paint (1) is diluted with water, it loses body and the color becomes lighter (2); on the other hand, if it is diluted with a medium (3), it becomes lighter but it maintains its density. When it comes to color, if you dilute a dense color from the tube or container, you make uneven gradations and blotches of color (4); on the other hand, if you dilute a fluid color the pigment will extend farther with very rich gradations similar to those of watercolors (5). This is because fluid and liquid acrylics have very refined pigments.

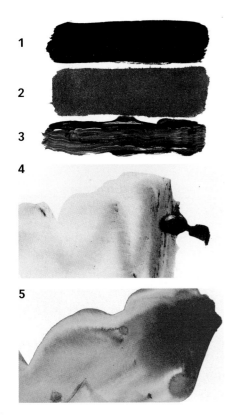

1

2

3

4

5

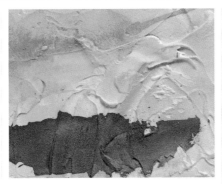

Very diluted paint applied over a textured background strengthens the relief.

If the paint is diluted with medium and applied over bases of still damp mediums or gel, you will create fluid strokes that make swirling forms.

Paint with Volume
One of the advantages of acrylics is that it allows you to create works with a lot of volume because the material responds superbly. This is because there are a great number of modeling pastes, gels, and fillers on the market. Keep in mind that all the gels and most of the pastes are transparent when they are dry, even though they are white when they are fresh.

You can prepare the relief first and paint over it with the color in its normal form, or paint directly with the relief, applying the thick paint with spatulas.

The pastes and gels can be mixed with the paint in any proportion that you wish.

When relief is added to an iridescent it will create very expressive metalized reflections.

1

2

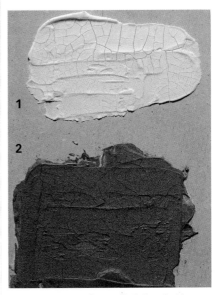

Crackle paste can be applied directly (1) as a base to paint over when it is dry, or it can be mixed with the paint (2), without losing its properties. If you decide to paint over it, you should apply very diluted paint. The thicker the layer, the larger the size of the crackling will be, and the thinner the layer, the smaller the cracks and lines will be.

Basic Techniques

CONTROLLING THE WETNESS OF THE BRUSH STROKE

The expressivity of the stroke comes not only from the gesture of the artist's hand but also from its own physical characteristics. It is very important to control the amount of moisture, since the paint reacts differently in dry, fluid, and wet states.

Dry on Dry

Dry strokes are those made with a dry brush, creating a rough and uneven mark. The open effect that is created in the paint makes transparent layers that create an optical mixture as the color particles are seen together. A dry brush stroke can be applied in two ways: by dragging, which is typical of any brush stroke, or stenciling, which consists of applying the paint by dabbing a small amount at a time to create a mottled effect.

Wet on Dry

A wet brush stroke is more uniform and covers more than a dry one. The color mixing is done on the palette because the layers you will paint over are dry. According to how transparent the paint is, you will see the underlying layers causing a fine and clean glazing effect similar to that of watercolors. In this case, an optical mixture is created in the eye of the viewer since the colors mix through transparency. This can be done with brushes and by dragging a spatula.

Wet strokes over dry. There is no blending, only transparencies.

Wet on Wet

This option makes great use of the fluidity of the paint. Whether using a brush or a spatula, dragging a wet color over another wet color causes blending on the canvas. It is one way of mixing colors, not on the palette but on the painting. However, there is a danger: the paint that is mixed sometimes makes muddy and uncontrolled colors. If the base is simply fresh paint, there is more control. If you do not make too many brush strokes, just blending without going over them too many times you will not muddy the colors. But if the base is very wet, puddles will form, and it will then be left up to fate.

Wet on wet brush strokes that create gradations and blending. You must act quickly to create this effect unless you have added a retarder to the paint.

Dragged brush stroke demonstrating dry brush over dry.

Stencil type brushwork with dry brush over dry.

Wet on dry, dragged with a spatula. The amount of transparency created depends on the pressure of the spatula.

CREATING BRUSH STROKES

The way a brush stroke is made determines the artist's calligraphy, his or her personal style. It encompasses the movement of the hand, the wrist, the forearm, and the entire body, according to the dimensions of the work and the dynamic character of the artist's style.

Gesture Painting

Four factors control a gestural stroke: the applicator, the amount of paint, the speed of the stroke, and its form or modulation. Gestural painting records the accidents of the stroke, its textures, and its corrections, since they all have their own forms.

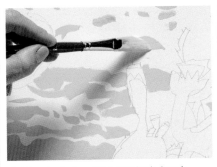

Flat brush stroke with a synthetic brush.

Dry Brush

This causes a visual blending of colors applied with very dry porous brush strokes that are superimposed.

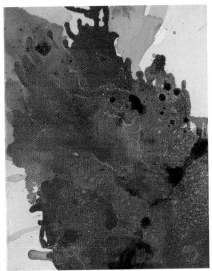

Wet glazing with drips and puddles.

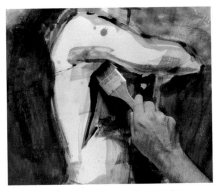

Modeling the gesture gives form to the stroke. The speed and the amount of paint combined cause dripping and splashing.

Flat Strokes

One of the classic acrylic techniques is flat painting. Since most colors are opaque and they dry fast, acrylics are quite agile when it comes to working with layers. To develop a flat painting, it is important to use brushes with synthetic hair, preferably flat ones. The color mixing should be done only on the palette, blending the paint well to create the desired color with a very uniform texture.

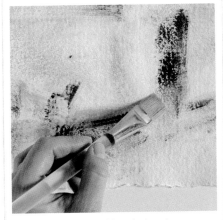

Brush stroke made with a dry brush.

Washes and Glazes

Since acrylics are a water-based medium, it is possible to create special strokes where water plays an active role. You can use it to create puddles where the pigment will spread, precipitate, or create rings or to generate forms by dripping and splashing. Finally, you can interrupt the drying brush strokes by opening white areas and washing them with pressurized water.

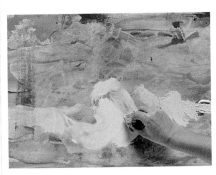

1

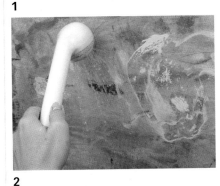

2

Wash applied directly from a faucet (2) on the paint (1) when it is not completely dry.

Basic Techniques

APPLYING SPECIAL TECHNIQUES

Agglutinated Materials

If you wish to make paint with diverse materials other than pigments, you only have to agglutinate that pigmented filler with latex or with gel in the proportions that best meet your requirements. If you are working with organic materials like spices, tea, coffee, or flowers, there is a risk that they will be ruined if they are kept damp for several days so it is best to prepare the paint and use it as soon as possible. Once it has dried on the painting, it will be completely adhered by the vinyl glue. Mineral materials usually work very well.

Green carborundum powder.

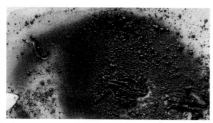
Medical iodine.

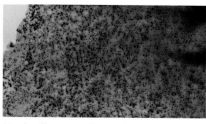
Pigment and green tea.

Used coffee grounds.

Reserves

These are used to clearly differentiate the areas of the painting or to preserve areas of it. It is usual to make reserves with adhesive tape and cut stencils. Tape works better on canvas than on paper because the fibers are not raised when it is removed. Paper masking tape is best, and it should not be pressed too hard when applied so it does not leave any traces when it is pulled off. Stencils are usually made of cardboard so they will have some strength, but if you are going to use them very much it is a good idea to make them from acetate so they can be washed and will last for a long time.

A reserve made with masking tape. If the layer of paint is thick, the tape should be removed while it is still fresh. If it is very thin, you can wait, but not too many days because the adhesive on the tape will harden and cause problems.

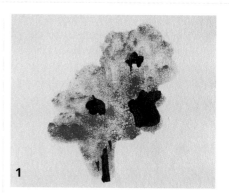
1

2

3

(1) Painting made with reserves using two cardboard stencils, one for the outside outline (2) and the other for the inside shapes (3).

Transfers

To transfer a printed image, choose a printed ink image from a newspaper or print, or a traditional photocopy (1), but not an inkjet digital print or a photograph. The photocopies are adhered face down (2) in a thin layer 1/24 to 1/12 inch (1 or 2 millimeters) of gel and left to dry for 24 hours. Later the paper is removed with water and light rubbing (3). The toner or the ink will adhere to the gel, and the paper will completely disappear.

Mixed Media

Acrylic is the medium that combines best with others. Since it is water-based, it works perfectly with any dry technique, and it is an ideal base for oil techniques. But there are some inconveniences. When applied over an oily medium like oils, wax, or enamels, the paint will slip and not adhere well. The solution is to use a base medium for glossy supports, which will create a porous layer over the slick background. Another shortcoming is that, after acrylics dry, they have a satin plastic finish that dry media like charcoal and pastel will not adhere to. In this case, you can use the same system of an intermediate layer of transparent acrylic base for pastels, or apply the original paint with a matte medium.

In a strictly experimental creative mode, it can be interesting to mix the acrylic with greasy substance like oils, enamels, asphaltum, and even turpentine. They will never completely mix because the oil and water repel each other, so you will achieve strange emulsions that generate brush strokes with very expressive visual textures.

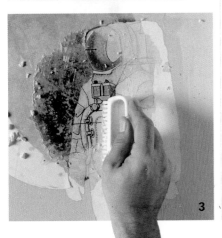

1

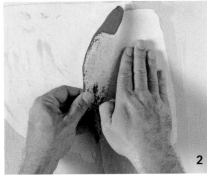

2

3

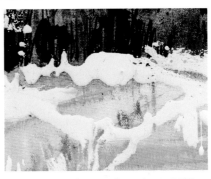

White oil enamel on acrylic and pastel. This creates contrasting surfaces with waters and lumps.

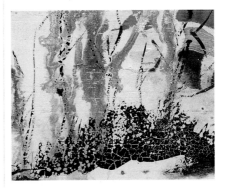

Silver oil enamel, white acrylic, and india ink. The india ink forms crackling and lines on the acrylic according to how wet the underlying color is.

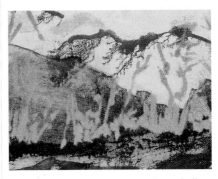

Liquid acrylic (for airbrush) with linseed oil and gold enamel. The oil and acrylic repel each other and form strange emulsions with textural effects.

Creative Techniques **Acrylics**

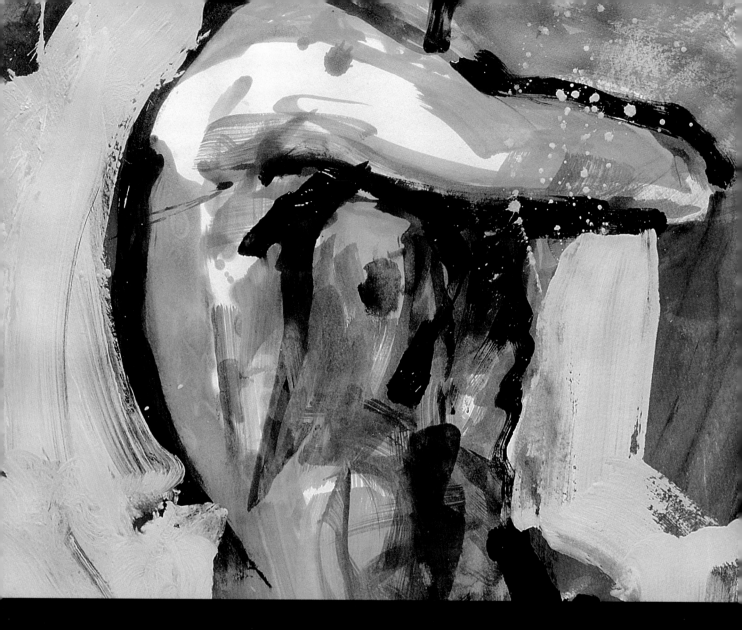

01 02 03 04 05 06 07

Creative
Approaches

08 09 10 11 12 13 14

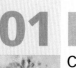

01 Dry Brush
Creative Approach

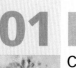

Albert Ràfols Casamada, *Objecte rosat*, 1981. Private collection, Barcelona.

There are subtle and quiet painters who are strongly lyrical and sensual; painters whose grave personal style is without brusque changes. This is the spirit that defines Albert Ràfols Casamada (born in 1923). In 1950 he abandoned his study of architecture and decided to dedicate himself entirely to painting. Later, in the eighties, he gained success and his work spread internationally. It was then that he perfected his technique, deciding to work in larger formats and to consolidate his own style. Influenced by Neo-Expressionism, his painting became denser and more vibrant, modifying the range of colors. He wanted "to express it all through color" and to create an inspiring, certain luminous atmosphere that could be associated with specific places. His works from 1981 were the most beautiful of his artistic career; they illustrated a transition from a composite geometric scheme to the strong luminous feeling that appeared later in his work. One of the emblematic paintings of this era is *Objecte rosat*. In it, the painter creates an ordered composition with a clear symmetric severity, the rectangle within the rectangle, which adds the pink object that appears situated on the edge of the line as if it were suspended in the air. The brush strokes are quick and create a dense and luminous atmosphere.

Creating Atmospheric Light and Color with Dry Brush Strokes

One of the characteristics of acrylic painting is that it dries very quickly, making it easier to apply the technique chosen here: dry brush. This consists of applying layers of paint over already dry paint. Each new layer is painted over a dry layer without entirely covering it, using a dry brush with little paint, making sure all the layers of color can be seen. For this first creative project, Gemma Guasch chose to paint a simple still life of flowers, superimposing layers in different tones, capturing the warmth and clarity of the atmosphere and light. She painted on a canvas board with pallet knives and flat, synthetic brushes.

❝But what is the theme of my paintings? It's something difficult to pinpoint. It could be said that the theme is the paint itself, or perhaps the light, but not a light that dilutes the form, rather one that configures, that defines, that invades the space. ❞

Albert Ràfols Casamada,
Notes on (his) painting,
2001.

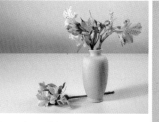

Step-by-Step Creation

1. To begin, a wide paintbrush is used to make a color background in a diluted yellow-orange tone. Next, the still life is sketched with a soft, light pencil (B).

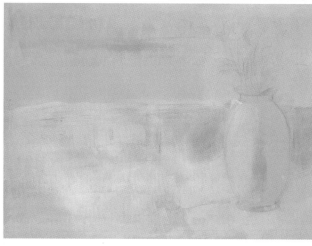

2. Using a flat brush, layers of dry paint are applied over the base, white on the background and orange on the vase, making sure all the layers of painted color show through.

3. When everything dries, the darkest areas of the still life are painted with Payne's gray: part of the background, its shadow, and the shadow of the vase. The branch located on the table is suggested with the same color. The paint is spread well so as not to hide the previous layers; the ideal instrument for this is a medium flat brush.

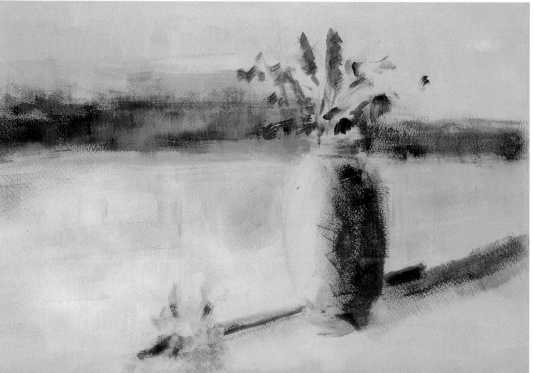

4. Using a narrow flat brush, the flowers and the leaves are defined with emerald green. Loose brush strokes of the same color are also painted on the background and the vase.

5. To contrast the painted bunch of flowers, thin brush strokes of the clear yellowish green are painted over the emerald green. Then, using a wide paintbrush and the dry brush technique, a thin layer of white paint is applied, allowing the previous colors to show through.

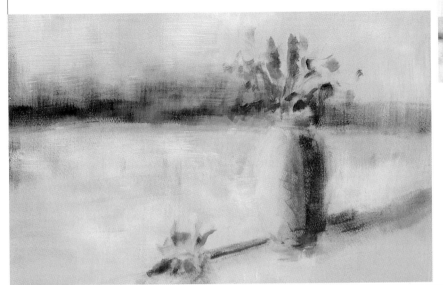

6. To finish, the pink brush strokes of the petals are suggested using a fine round brush and carmine paint. Layers of white are painted with a paintbrush to increase the atmosphere and create a complete dry brush effect.

By overlapping thin layers of different colors, dry brush creates a rich and expressive atmosphere. Knowing how to combine the colors and apply each layer well is the key to mastering this acrylic painting technique. In this gallery, we used different supports, applicators, and colors to create the paintings.

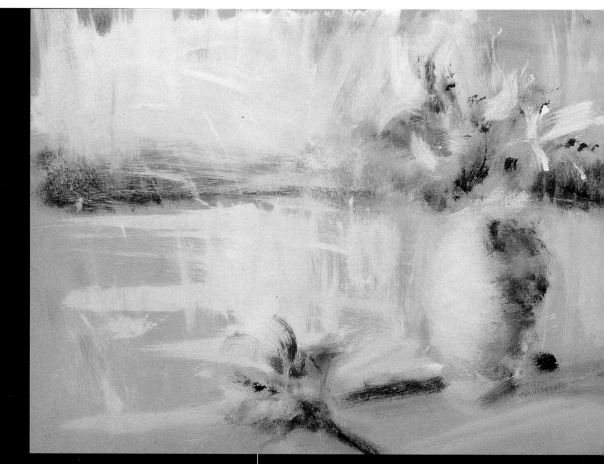

A pink color paper was chosen for this work, and paint was applied directly with a cloth. This allows us to paint quickly and spontaneously, easily spreading the paint with the aim of creating a gestural and dynamic still life.

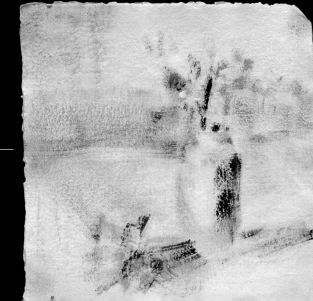

The still life was painted on handmade paper with a wide paintbrush. The paint was applied dry and in thin layers of color that allow the texture and the white of paper to show through. The outlines of the brush strokes do not detail or "draw" the still life, but they do create atmosphere. The final result is bright, direct, and fresh.

Dry Brush

Creative Techniques **Acrylics**

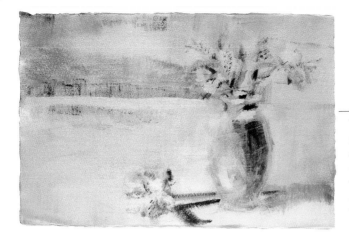

This piece has been painted on handmade paper with a flat brush. The dry brush can be seen in the gray tones of the vase, which are covered by a thin layer of white. In addition, the grayish tones were darkened while still allowing the white of the paper to show through. The final result portrays a simple and expressive atmosphere.

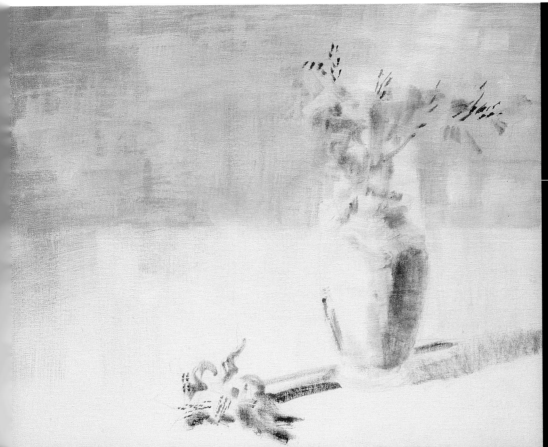

The most atmospheric artwork of the gallery was painted using a flat brush on a canvas board. The color white covers the entire painting and envelops it in an aura of elegance and delicacy. The carmine tones are painted with a fan brush, slightly varying the brush strokes and adding energy to the work.

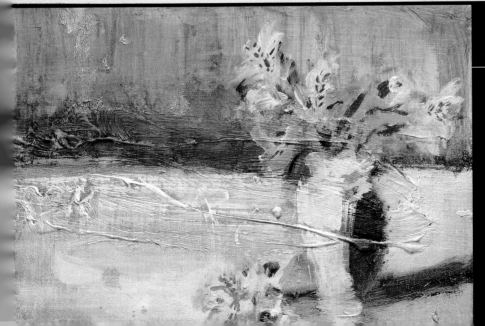

In this instance, we recycled a canvas board that was already textured and filled with paint. The dry brush increases the texture when done on an irregular surface. The thick paint adds fullness and strength to the atmosphere.

Creative Techniques **Acrylics**

01 Window

New Approaches

Another point of view Another way to tackle the still life and preserve the atmosphere is to maximize the intensity of chromatic notes with saturated colors. In this instance, reds, blues, and yellows replace the whites. The smoothness and delicateness of the white atmosphere are completely changed by painting with strong, vivid tones. The colors provide strength and energy to the atmosphere, as well as a feeling of magic and imagination. This was painted on a canvas board with various synthetic flat wide brushes that were changed to avoid mixing the different colors into unwanted grays.

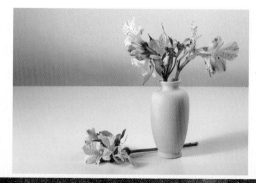

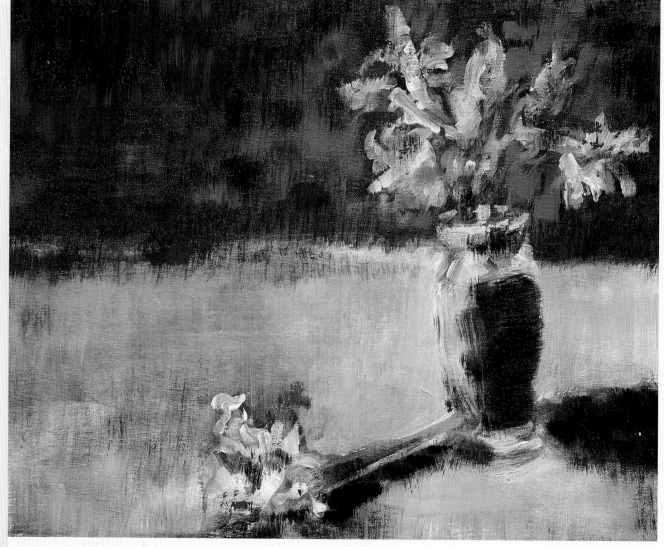

Another model To move away from the white and luminous atmosphere of the previous still life and to experiment with a tenebrist, dark contrast, Gemma Guasch painted a nude work using the dry brush method. This nude is strongly and theatrically illuminated, which exaggerates the volumes and causes them to contrast strongly. To darken the background and part of the figure, the painter mixed the colors sap green and cobalt violet with black to give them a special tonality. After capturing the contrasts of light on the body, she only painted over the illuminated parts, leaving the rest of the body submerged in the darkness of the background. She did the painting using the dry brush method on pressed cardboard with a synthetic flat brush.

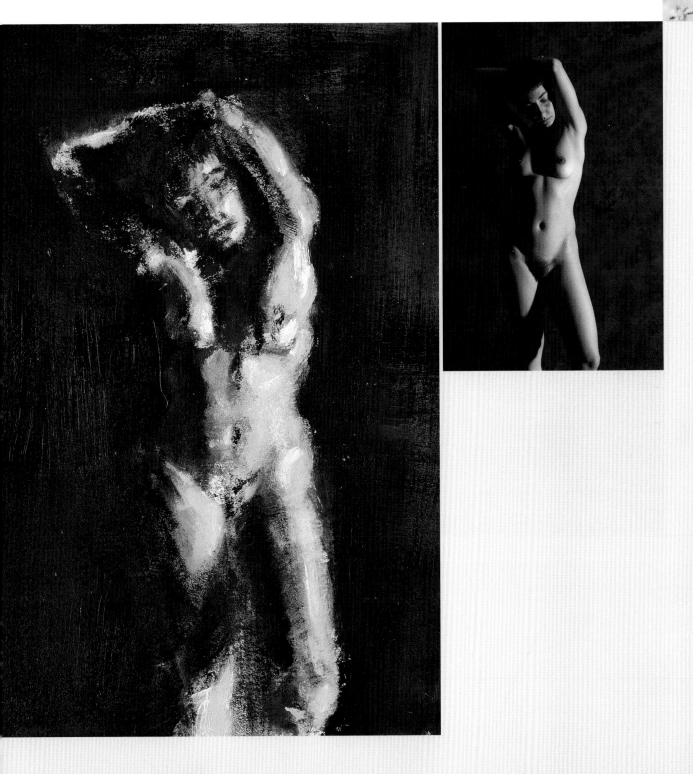

02 Watercolor Painting
Creative Approach

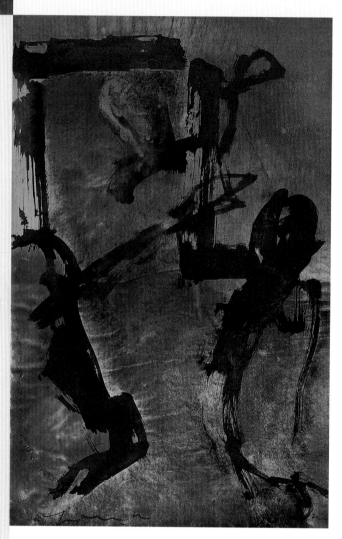

Perico Pastor,
Esquinazo, 2005.
Private collection.

Perico Pastor (born in 1953) subscribed to the style of painting that emerged around the last quarter of the 20th century. This style evolved in different countries as German Neo-Expressionism, the New York style, or the Italian Transavantgarde. The work of this Catalan artist is characterized by its great visual clarity and by the light emerging from within the colors. He began his career in New York as an illustrator, returning to Barcelona during the 1980s, where he continued to work as an illustrator and from where he launched his paintings internationally. His lyrical expressionism is based on two geographical and conceptual poles: on the one hand, the light, the color, and the translucence of his native Mediterranean sea; and on the other, the energy of the gesture and the value of the empty spaces, typical of Chinese paintings. His esthetic style, which emerges from the sheer pleasure of painting, bridges the distance between these two poles. His work is an invitation to happiness and peacefulness. The recurring themes of his paintings represent daily scenes where he includes people posing naturally, relaxing, or enjoying the moment, displaying certain pictorial eroticism that is expressed through the sensitivity of the color and his direct and pleasant lines. His figures are an invitation to rediscover the body spiritually, through color and light, and humanly, through his masses and volumes. *Esquinazo* is an acrylic painting that could certainly pass as a watercolor because of the brightness of its diluted colors, which are reminiscent of stained glass windows.

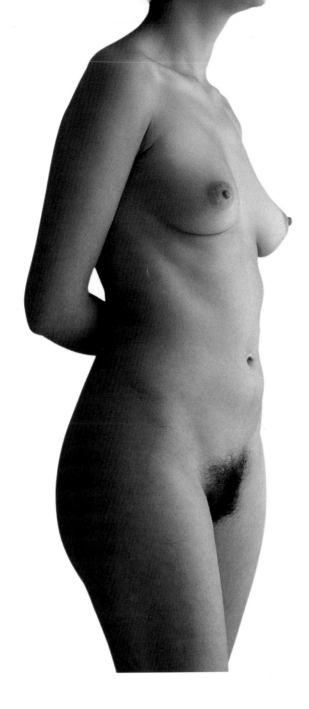

Painting in the Style of Watercolors with Acrylic Washes

Acrylic paints, like watercolors, are a water-based medium, which makes it possible to achieve very similar effects with them, but not exactly the same, since the agglutinate is different. In this approach painted by Josep Asunción, the acrylic paint is very diluted to maximize the transparency of the color. The support is paper so the artist can use the porosity of its fibers to easily create multiple superimposed transparent layers. Like Perico Pastor, the author used the high water content of this technique to his advantage to create expressiveness, producing gradations and puddles that spread the pigment. The artist used synthetic bristle brushes, and the model is a female nude.

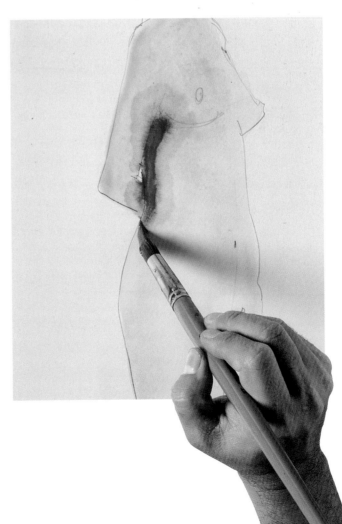

<< *Now that time has elapsed, I know that those first idle or sleepy characters by Perico Pastor did not guide me to the antechamber of limbo, but rather to that of the mirrored room where happiness resides.* >>

Llàtzer Moix, *1992*

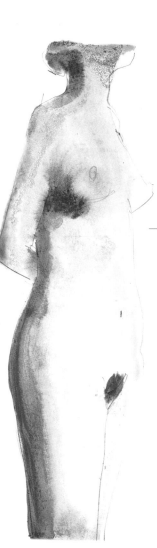

Step-by-Step Creation

1. The first step is to create a very clean blocked-in drawing since the colors that will be applied over it will be transparent and the lines will be visible. Use a medium lead pencil without applying too much pressure to prevent damaging the grain of the paper.

2. The area inside the torso is lightly moistened with water tinted with a light color. The artist has selected a manganese blue tone for the chiaroscuro light, a cool color that will stand out against the warm shadows that will be created by spreading the wet blue color.

3. While the paint from the blue silhouette is still very wet, we create the shadows of the torso. We use a thin, round brush and light red cadmium acrylic paint. Without wetting the brush too much, we draw the shadows along the edges of the silhouette, in such a way that the wet blue areas form natural gradations, while distributing the red pigment inside the figure as desired. We suggest testing this on a piece of scrap paper to see how the water content affects the blue paint and the creaminess of the red.

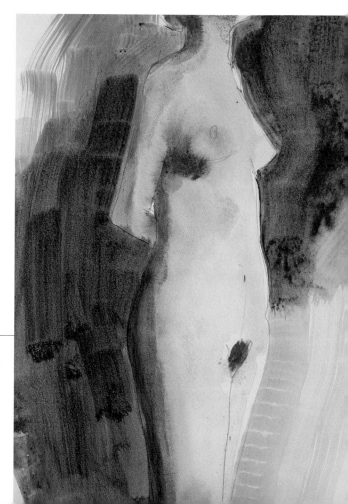

4. The next step is to paint the background with a color that is darker than the figure's areas of light; this way, the light of the painting will be on the torso and not on the background. Since we have decided that the shadows will be red, we paint the background red as well; this creates a tenebrist effect that is colorist at the same time. To prevent the volume of the figure from smearing, it is important to wait until it dries before using the wet brush without worrying about diluting its contours.

5. When the color of the background is dry, a third color is added to the painting, this time a very diluted green. Since this color is the complement of red, it can produce two results: when the green is next to the red, it produces a vibrant contrast, or, when the green is painted over the red as a transparency, it can neutralize it.

6. To finish it, we redefine the figure using a round, thick acrylic bristle brush with a pointed tip. This brush can paint very expressive lines for the contours and also sinuous areas of color for the new shadows of the body and the background. We return to the blue color again, less diluted this time to make darker lines.

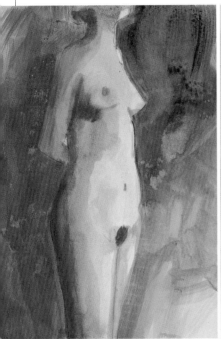

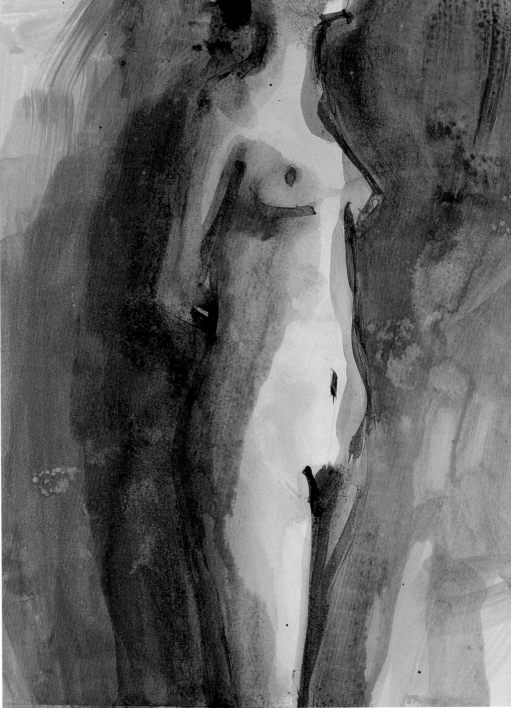

Watercolor acrylics can produce very clean and fresh looking results, but also very atmospheric and dense finishes. In these pages, we can see the different possible finishes depending on the number of transparent layers of color that are applied.

This acrylic painting on handmade paper is the closest thing to a traditional watercolor because most of the paint applied is very transparent. In addition, the artist used the white of the paper to express the overall light of the work and has integrated the drawing pencil completely. The result is very fresh and also very precise.

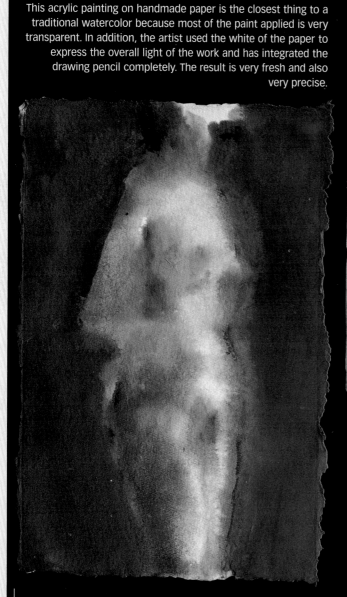

Very saturated colors have been applied wet on wet, on handmade paper. Painting with so much water results in very extreme gradations with an airy and light finish that resembles clouds or cotton balls. There is always the risk of diluting the forms too much, but that is the appeal of this technique.

This is the most atmospheric work of the gallery. Its atmospheric effect is due to the great number of transparent layers that act as glazing, which gradually add intensity and texture. The torso's blue silhouette separates the figure from the background but it still has the same overall, warm light.

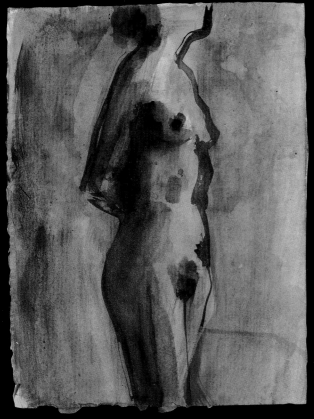

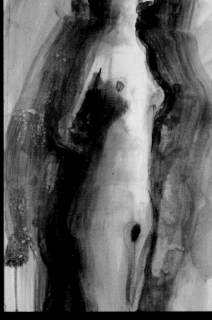

The expressionistic effect of this painting is the result of vigorous and quick brush strokes over the background and on the figure. Also, a tenebrist effect was achieved by applying very dark shadows of dense colors and very soft lights, not using white paint, but the white of the paper as in traditional watercolors.

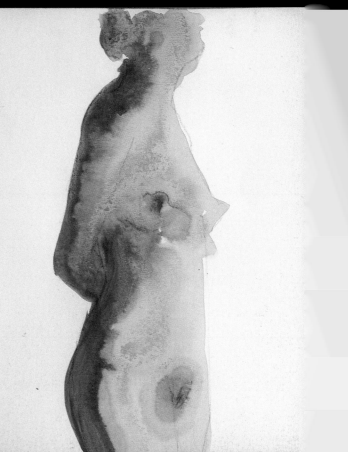

This work on watercolor paper was painted in stages, letting the paint dry between them. The first step is to paint the figure wet on wet to achieve an extremely airy feeling. The second is to paint the background green to make the silhouette stand out against it again, and the third, to cover that green with opaque black allowing the layer underneath to partially show through to avoid obstructing the background.

This is the simplest representation of them all. It consists of synthesizing the body of the model with splashes of color. The artist used two colors, blue and red, which were applied on a wet surface, letting the water in the paint flow spontaneously to creatively suggest the modeling.

02 Window

New Approaches

Another point of view In all the paintings from this project, there is a logical relationship between the colors and the theme because we have maintained a certain level of realism despite the creative license taken with the color. To further explore the creativity, the author is addressing the forms as well as the color. The results can be found in the boundaries between realism and abstraction. The female torso is recognizable, but in an undefined and unfinished way. This effect has been created by working with color spontaneously, and without a pencil drawing to define the form of the body.

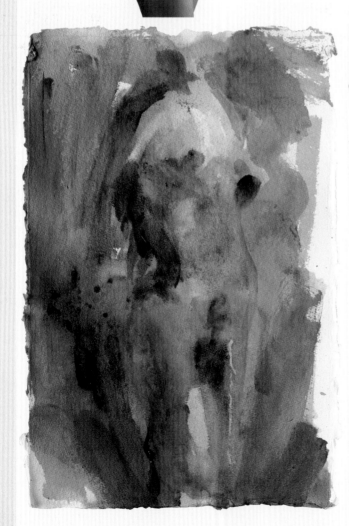
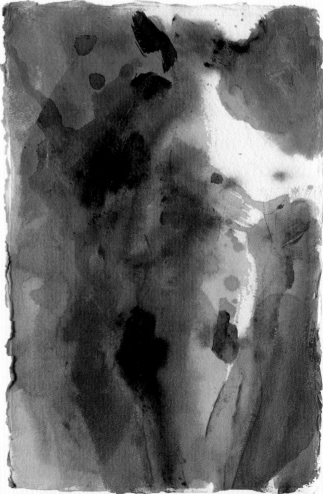

Another model To change the theme completely, now the artist is experimenting with an organic composition that has no background or defined shapes. Here, the paint has the same value as the background and its elements: the fruit, the branches, and the leaves form a visual texture created by layers of different shades of green. The final painting is very airy, like a landscape full of atmosphere, texture, and color. The diluted acrylic paint allows this effect because many transparent layers produce greater depth than a single area of color, which is much flatter and solid.

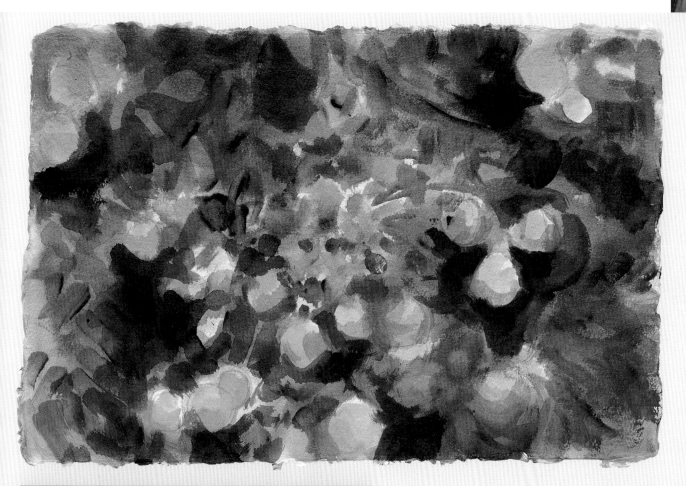

03 Textures with Fillers

Creative Approach

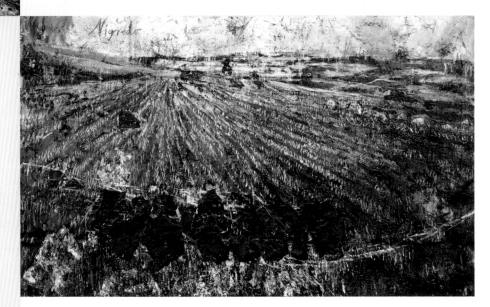

Anselm Kiefer, *Nigredo*, 1984.
Philadelphia Museum of Art
(Philadelphia, USA)

One of the main advantages of acrylic paints is their textural possibilities. They are the result of the different polymeric glues, which are highly adhesive, and the agglutinates, which make it possible to add different fillers to the paint to increase its volume and to add texture. One contemporary artist who has experimented a lot with fillers is the German Neo-Expressionist Anselm Kiefer (born in 1945). Kiefer emerged on the art scene during the last decades of the 20th century and was known as a daring transgressor of conventionalisms because he dared to incorporate unconventional materials in very large scales, which were monumental at times. In his paintings, he includes pieces of carbonized wood, lead, clay, dust, stones, straw, wires, and much more. Although the purpose for the use of these materials is driven by their pictorial and universal effect, there is a philosophical element to the decision for using them, whether it is the symbolism or their energetic charge, or to bring the work close to an alchemic level, as he himself expressed it: *"Constructing a painting is an alchemic endeavor (. . .), I expose the painting to inclement weather and wait for changes to take place. A painting acquires a life of its own overnight."*

Creating a Textured Landscape Using Mineral Fillers

The goal of this creative approach developed by Josep Asunción was to play with the textural possibilities of acrylic paint on a panoramic landscape with a central vanishing point. He did this by using fillers he prepared himself, using gel and marble dust of different consistencies, as well as commercially available, already mixed paste that contains mineral fillers, like pumice, granite, and mica. He used canvas board because a strong surface was vital for this project. He mainly used a spatula as the applicator, as well as a brush for the details.

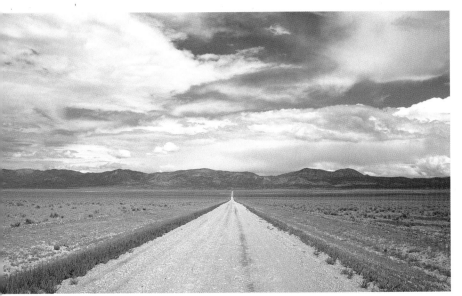

"R.A.: No matter what, what you want mainly is to work with the material, right?
A.K.: No, that is not correct. What I am interested in is any type of material as long as it is filled with something, that is, when it encompasses the spirit. "

Anselm Kiefer,
Interview with Roberto Andreotti, 2004.

Step-by-Step Creation

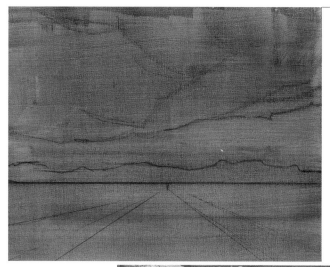

1. We begin the work by laying out the main basic lines of the landscape with charcoal: the horizon, the vanishing lines of the road and its margins, the outlines of the mountains, and finally, the large cloud masses that become larger as they move toward the horizon. We will use a background color that will stand out in contrast against the areas that are left unpainted. Since the landscape has cool colors, we select a warm base to add chromatic tension.

2. We use two tones of blue (royal for the skies and indigo for the mountains) acrylic paint mixed with a filler of regular gel and marble dust. The texture obtained is similar to fine sand, slightly rough with pores and irregular edges. To keep the horizon sharp, we use a wood board placed along the horizon line. It acts as a barrier to prevent the paint from spreading beyond that border when we draw the edge with the spatula.

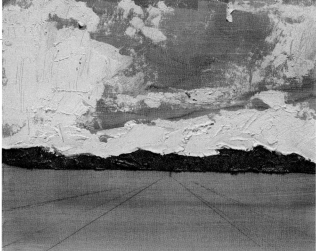

3. We continue with the marble dust, but this time we mix it with the medium tones of the royal blue sky and the green base of the fields. The direction of the brushstrokes are handled carefully to model the space to create depth on the land and volume in the clouds.

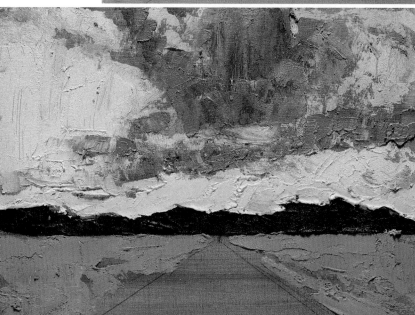

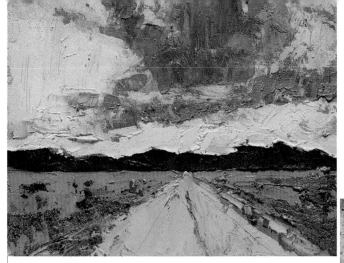

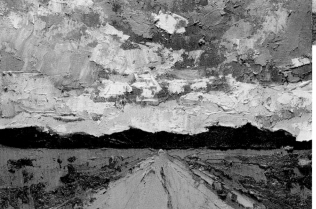

5. We continue adjusting the forms and light on the sky, without altering the filler, to avoid excessive dramatic effects and to maintain the textural differentiation between the ethereal sky and the physical and heavy ground. We add areas of blue cobalt and gray blues with raw umber.

4. We continue with new textures on the ground of the landscape by adding a heavier filler of gel and marble sand to the paint, much heavier than the marble dust. The heavier and thicker the filler, the less precise the stroke; therefore, we work by adding impastos carefully to avoid disturbing or dragging the mass of paint too much and leaving the previous thin paste and part of the red background exposed.

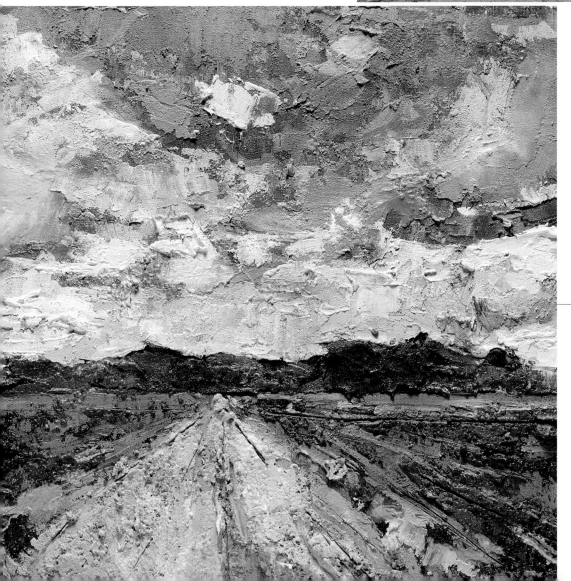

6. Finally, we adjust the areas of light on the landscape by adding touches of raw sienna to the ground, burnt sienna to the mountains, and new strokes of white to the sky, with a brush or a spatula, as well as pure royal blue sparingly to brighten up the color.

Creative Techniques **Acrylics**

03 Gallery
Other Versions

The following gallery shows the different results obtained by using different fillers. Each filler requires a different applicator since the paint acquires a different volume and weight. Despite using the same colors the effects achieved are very different.

This painting has been done with granite filler. The granulated effect is visible given that this mineral is thick and heavy, and very hard as well. The granite produces interesting effects similar to gravel on the ground but static and stone-like. The thickness of its particles generates larger shadows, adding a dramatic effect to the painting. To avoid overdoing this effect, we left an area without filler so we can later add fluid brush strokes of blue and thus add dynamism.

Here we used pumice stone filler. This mineral is very light and fine; therefore, the resulting texture is soft even though it is porous and uneven. The pumice does not produce the visual effect of heaviness, and it can be applied with a brush. In this painting, we can see the marks of the spatula and the brush strokes intertwining perfectly.

This painting was created basically with the mass of the paint itself and a lower ratio of very light filler of modeling paste and pumice, which is available already mixed. Since the acrylic paint is creamy, there is greater unevenness and heavy relief effects when dragging the paint. We have used a spatula and a round bristle brush to deepen the lines and to create relief edges. The result is fluid and dynamic.

The dynamism of this painting lies on the irregularity of its textures. To achieve this effect the artist mixed the paint with filler made of dried paint scraped off the palette with a scraper at the end of a painting session with acrylics, and latex. The blotches of color add spontaneous and whimsical relief effects that blend very well with the fluid brush strokes of color.

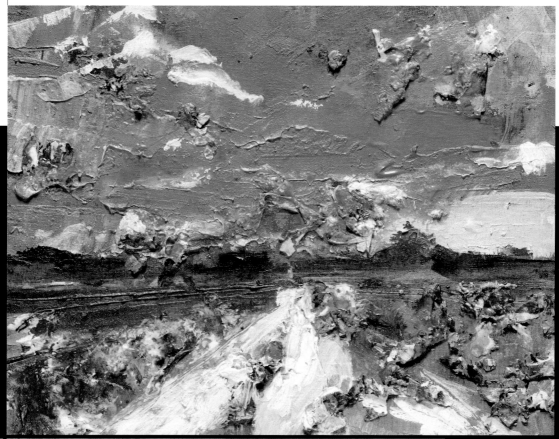

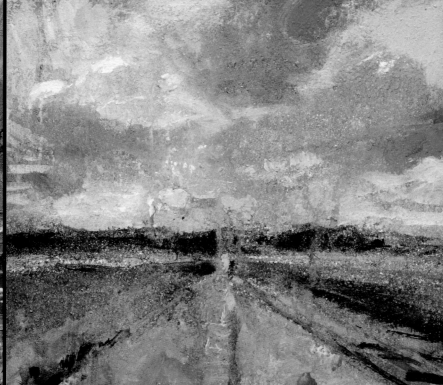

This time, the paint was applied very diluted over an already dried textured base. For the base, the artist used a filler of mica, a mineral that is crushed into minute flakes that have a metallic tone. Mica is sold already prepared with the gel, as a relief paste with filler. The resulting effects can be very artificial looking due to the exaggerated shine that it creates, although that excess can be toned down with color glazes.

Creative Techniques **Acrylics**

New
Approaches

Another point of view To create this different approach, the artist chose to use the same landscape, this time leaving out the color completely to focus more on textures. The gray tones range from light to shadow, establishing a very interesting dialogue between areas of light and mass. Visually, we associate light with the intangible, with lightness, softness, and airiness, and darkness with density and heaviness. Breaking up that perceptive logic in some areas adds tension and intrigue to the painting making it more interesting.

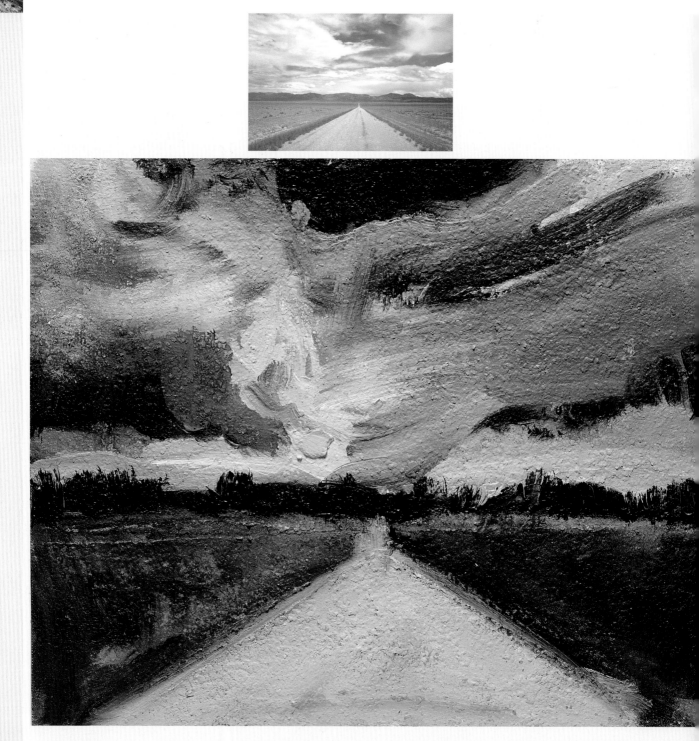

Another model The landscape in this Creative Approach is panoramic and has great depth, which is the result of perspective and chiaroscuro. To change the theme, he artist chose a very different landscape, a bird's-eye view of farmland. In addition, this time there are no other features than the marks left by the harvester on the ground, which is an invitation to explore scratching and sgraffito techniques to the maximum. Scratching volumes and textures produces very expressive effects that resemble the most rudimentary graffiti, like the carvings on the bark of a tree trunk or cave paintings, which represent the human touch, their traces. To highlight the scratched lines, the artist chose a color background on handmade paper primed with black acrylic paint.

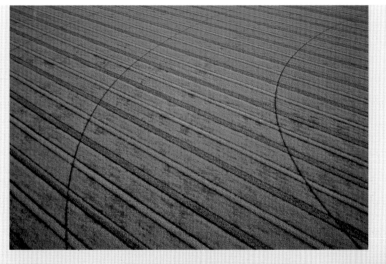

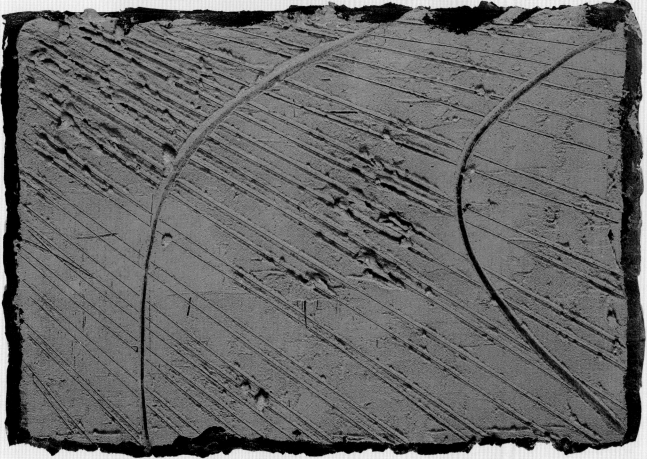

04 Flat Painting
Creative Approach

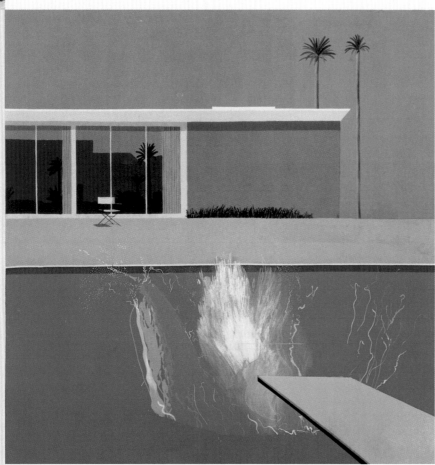

David Hockney,
A Bigger Splash, Tate Gallery, 1967.

Pop culture, which is defined as the culture of masses based on stereotypes and simplicity, emerged on the international art scene in the 1950s. Pop artists preferred comics to novels and created icons out of consumer products like Coca-Cola. In London a group of intellectuals reflected on modernity and its images. David Hockney (born in 1937), a multi-faceted artist (painter, printer, draftsman, and photographer), with an ironic and ingenious personality, and a very talented designer, was among them. Popular culture would be his source of inspiration, something that is still very recognizable in the subjects that he chooses, for example the famous swimming pools of Los Angeles painted in the 1960s with a deliberate naive and colorist point of view. *A Bigger Splash* is one of his most famous paintings, which was painted in his favorite style, using flat surfaces of acrylic paint. Hockney, like his contemporaries, sees in European Pop Art the natural evolution of Surrealism and Dadaism, which is why he never abandons the qualitative and intellectual value of painting.

Using Fast-Drying Paint for Flat Areas of Color

Gemma Guasch chose a cactus plant near the ocean as the model for this step-by-step exercise. The undulating forms of the water and the round silhouettes of the cactus are very appropriate for working with flat forms. The stylized shapes were drawn first to facilitate a flat and cutout version of the form. The artist painted this project on very heavy smooth paper using flat bristle brushes of different sizes. Even though the acrylic paint alone is a good material for creating flat forms, a medium was added to it to exaggerate this effect.

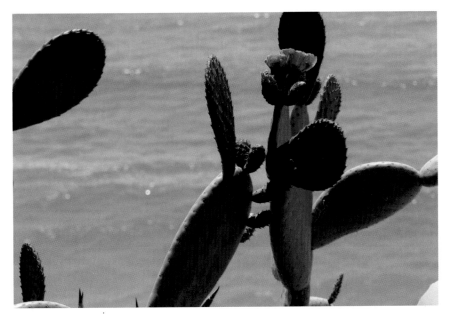

"My conscious feelings about machines, advertising, and mass communication are probably not the same as those of previous generations, which have lived without them. I grew up with them, so it is natural for me to use them without even thinking about it."

Peter Phillips, 1964.

Step-by-Step Creation

1. The artist blocked in the cactus plant with a soft HB pencil, synthesizing every shape as much as possible and exaggerating its roundness to define the work with the greatest possible simplicity.

2. The artist begins to paint the shapes of the water with the lightest color, lemon yellow mixed with a small amount of white. To do this, she used a flat brush to make it possible to cover large flat areas of color with a single stroke of paint. It is important not to add water to the paint and cause varying intensities, the areas of color must be even and smooth.

3. When everything was dry and there was no fear of inadvertently mixing the colors together, she painted the darkest colors of the cactus with burnt sienna using a different brush, which this time was flat and thinner. She worked on accentuating the roundness of the forms when painting the colors.

4. She continued to paint the cactus, this time with turquoise blue applied with two flat brushes, a wider one for the interior and a thinner one for the color where the edges meet the previous color. When finishing the painting, if the boundary between the colors is not perfect it is better for the blue color to overlap the burnt sienna; then it can be corrected when it dries.

5. The rest of the water was painted with light pink, which is the result of mixing magenta with a large amount of white and a little bit of yellow. She applied it with a narrow flat brush. When she painted the water, the color overlapped the other colors naturally, as it did with the cactus. Once again the shapes can be adjusted once the paint dries so they look even and flat.

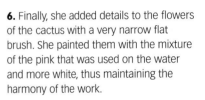

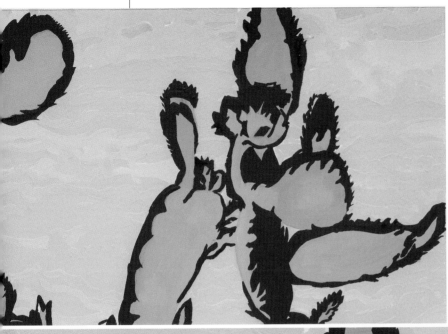

6. Finally, she added details to the flowers of the cactus with a very narrow flat brush. She painted them with the mixture of the pink that was used on the water and more white, thus maintaining the harmony of the work.

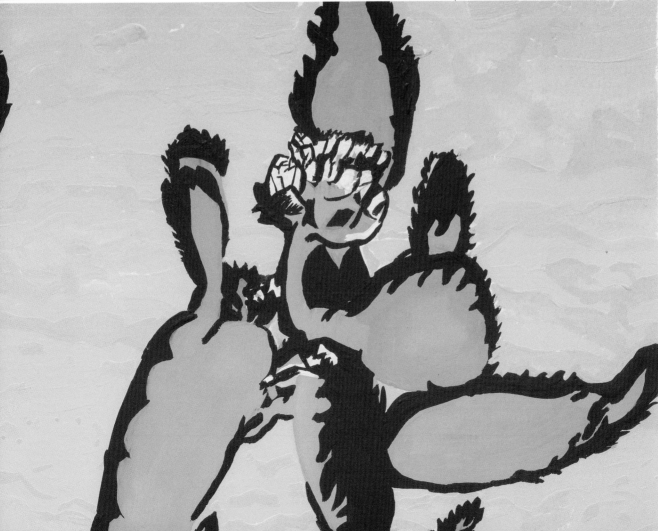

Gemma Guasch organized this gallery based on the concept of synthesis and flat areas of color and on new ways of seeing the forms by unifying shapes and colors. Keeping in mind the characteristic flat effect of acrylic paint, sometimes she modified the forms, and other times the colors. She used flat brushes of many different widths.

Here, the artist has reduced the forms to four colors: two blues, one green, and one orange. The orange color can be seen through the green, and it is the only light on the cactus. This is the darkest painting of the gallery.

This time, she simplified the forms, which have been painted in a harmonious range of orange and yellow tones. The water has been reduced to a single color emphasizing the flat character of the paint even more. This is a simple and striking piece.

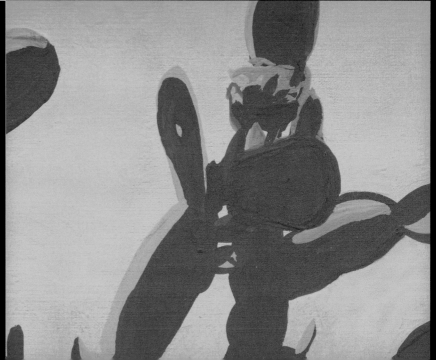

In this painting the artist has chosen an appealing chromatic contrast of complementary colors: pure magenta and two greens, dark and olive. The complementary contrast is softened because of the light values of the greens. Unlike the water, the forms of the cactus are carefully defined. The resulting painting has great contrast and elegance.

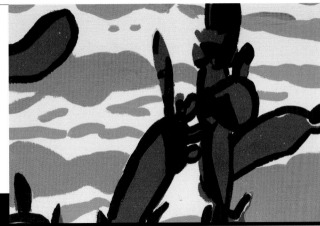

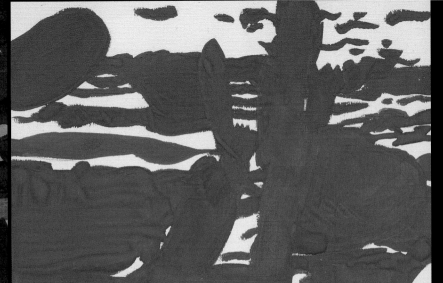

This is the most radical and wild painting of the gallery. Even though the cactus and the water can be perceived as separate, they are painted as a single form in ultramarine blue.

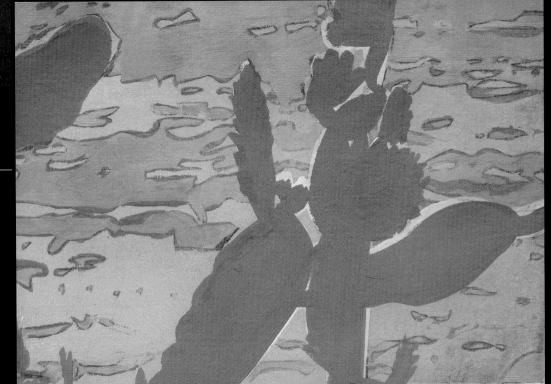

This work was painted with ochre and yellow tones. The cactus was painted with a single, striking ochre color, while the water, on the other hand, was painted with a layer of more diluted paint through which we can see the previously blocked-in lines.

Another point of view In all the previous pieces the flat areas of paint were full of emotion, in terms of color as well as line. Here, to achieve a different point of view, we have chosen a cooler, harder, and more analytical approach. To do this, first we have hardened the forms by outlining them with a thick, black line; then we used primary colors, lemon yellow, magenta, and cyan, which provide great energy and vitality to the painting because of their purity and saturation. The artist used different flat, wide brushes to paint the colors with a direct approach, with a single stroke, and without details.

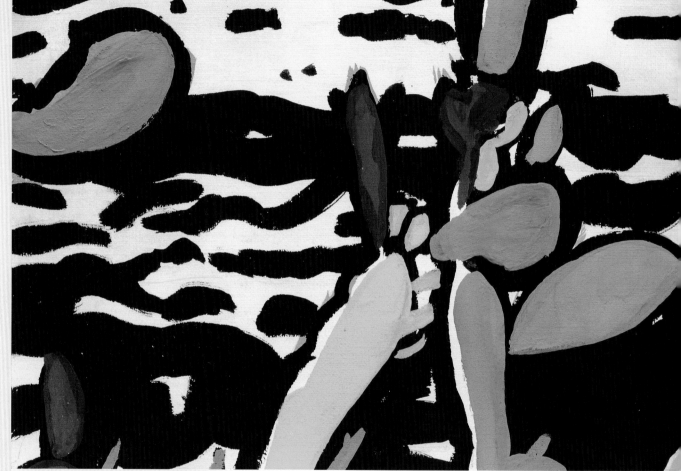

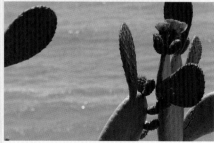

Another model The model chosen this time is very different: a simple building. It consists of large, flat areas of color, straight lines, and a clear perspective. Its author, Gemma Guasch, ignored the textures and details in favor of simplicity and synthesis. This way she could paint it with large, flat blocks of color and a range of fresh, sharp, clean colors. She used flat brushes of different widths.

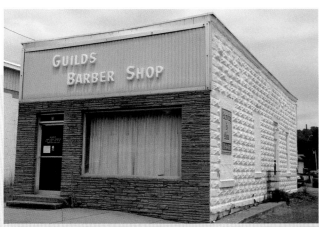

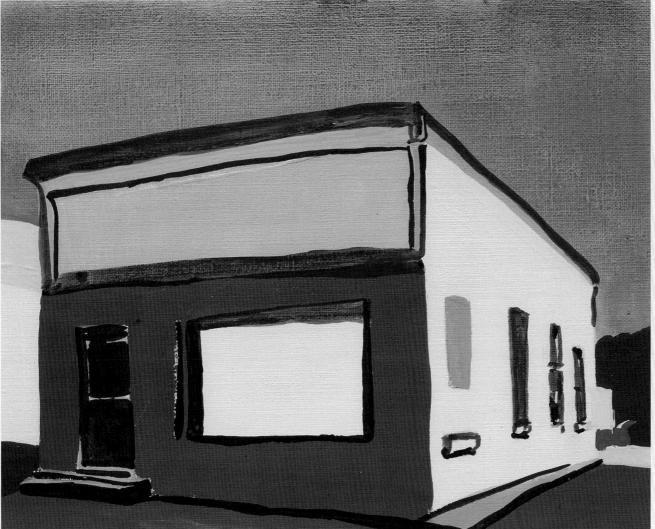

05 Agglutinated Materials
Creative Approach

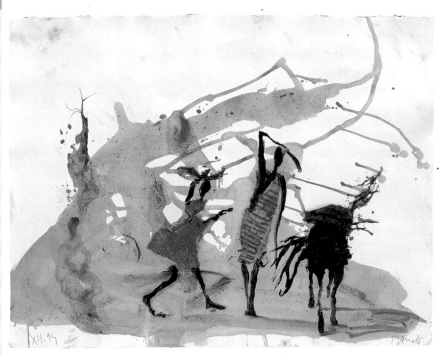

Miquel Barceló, *El asno cargado de madera*, 1994. Private collection.

One of the major advantages of acrylics is the simplicity of their composition: pigment and polymer glue (usually latex). This simple combination has inspired many artists to mix their own colors very easily by using commercial pigments or other solid and liquid substances. Miquel Barceló (born in 1957), one of the most important contemporary painters, has mixed his own paints from the beginning of his career to control the density and texture of the colors. From his time in Mali, which dates back to the 1990s, he has incorporated African clays and natural pigments. In his diary, on January 23, 1991, we can read a detailed description of those new additions to his palette: "Kaolin–indigo–ebony dust. Yellow and red clay from the riverbanks, coconut fibers, dubious pigments from the pollen of flowers. A stable color: mostazasenoufo-dogon. Ajami asphaltum (used by the women of Burkina and Ghana to decorate the façades of their houses and make them waterproof at the same time . . .)." In the work *El asno cargado de madera* (The Ass Carrying Wood) we can see clays, pigments, and some natural fibers, as well as a piece of burlap and a piece of paper, all of it bound with latex, depicting an everyday African scene with great realism and lyricism.

Making Your Own Paint with Agglutinated Pigments and Materials

It is very appealing to plan a creative approach like the one presented by Josep Asunción, experimenting with acrylic paints mixed with pigments and other unconventional substances. The artist has chosen the following coloring agents: coffee, various types of tea, iodine, and several natural pigments purchased in Florence, an area of Italy that is very rich in earth colors, and he has mixed them in cold latex. The artist drew his inspiration from a seagull in flight, which he painted on paper with a wide synthetic brush and brushes of other types.

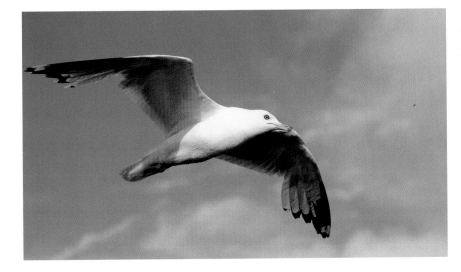

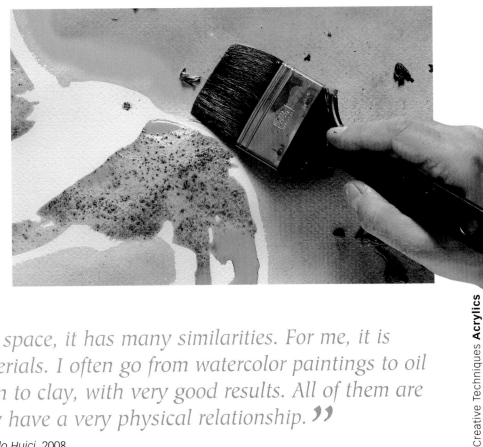

> *Clay is like drawing in space, it has many similarities. For me, it is healthy to change materials. I often go from watercolor paintings to oil paintings, from gypsum to clay, with very good results. All of them are handmade things, they have a very physical relationship.*
>
> **Miquel Barceló**, *interview with Fernando Huici,* 2008.

Creative Techniques **Acrylics**

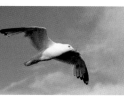

Step-by-Step Creation

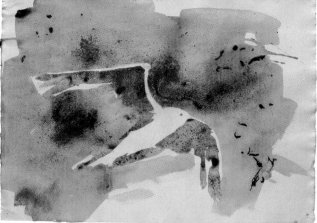

1. The first lines were painted with a wide synthetic paintbrush directly on the paper without a preliminary drawing, approaching the work from an expressive and daring point of view. The first brush strokes have an earthy quality that is created with a mixture of coffee and diluted latex. The artist only paints the shaded parts of the seagull, leaving the rest white.

2. Next, he paints the background with a very concentrated infusion of tea and mint, combined with latex. A few tea leaves have been left in the mixture to add texture.

So latex is sticky? (isn't add/mod pods?)
← Gloss? Paint instead and then tea leaves for texture?
how to make them shoe? apomie puddles of paint?

3. With a very dry, fan-shaped brush, he sprinkles pigments over some of the areas of the painting, using the puddles of water and latex as the base to adhere the dry pigment. He uses Venice and Morellone red, two earthy tones from the Tuscan region of Italy.

but wont it dry eventually so why shake?

4. When the paint is completely dry, he shakes it to remove all the loose pigment that has not adhered naturally. The pigment that fell on the dry areas of the paper is erased to remove it completely and thus recover its initial white color. You should not rub the pigment with either a hand or a rag since it would lose its sprinkled effect and smear. If the paint sticks to the finger, you can apply Shellac, or a spray fixative should be applied to consolidate it, especially if paint sticks to a finger?

what to use instead of finger?

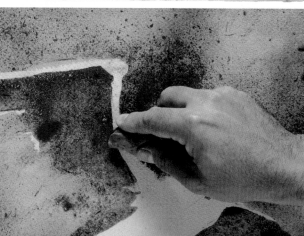

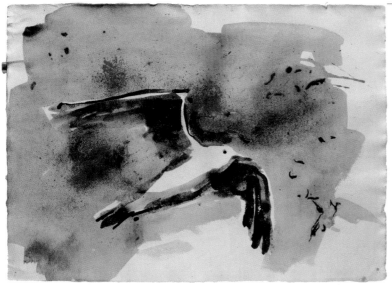

5. To define the outline of the bird he uses a mixture of iodine, Morellone pigment, and latex, to draw a few contour lines that need to be reinforced, as well as the shaded parts of the wings with their plumage.

Cant use just acrylic paint instead But I want to be able to write lines down solidly

6. To finish, he gently wipes the painting with a brush moistened with water to dilute the pigments a little bit and to soften the image. Once the paint dries, the final result loses its brightness but gains in atmospheric effect.

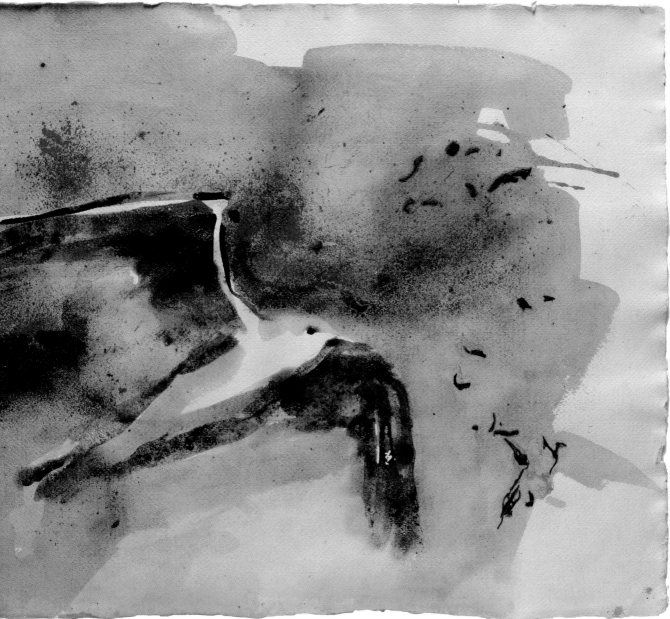

Creative Techniques **Acrylics**

05 Gallery
Other Versions

Mixing paints with natural substances like tea or coffee, combined with pigments and latex, is an inspiration for experimenting with paint that has texture that is part of the color itself. In this gallery, we can see how different the results can be depending on the substance that is used.

This is a more subtle and simple painting created with two simple areas of color: one for the sky, done with a Chinese red tea, and the other for the shadows on the bird, created with coffee grounds mixed with latex. The artist has used the white of the paper, as in watercolors, for the light areas of the seagull. The effect is fresh and poetic and still full of expressiveness.

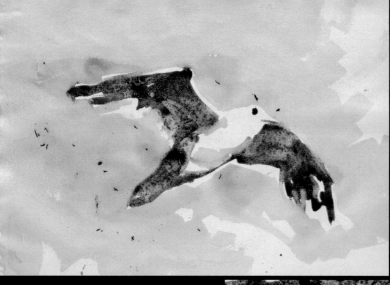

In this painting we have used coffee grounds, Morellone paint pigments, Spanish white, and concentrated tea made from blackberries, which gives it a purple violet color. The result has great expressiveness and chromatic power. By texturing only the sky and giving the bird strong contrasts of light and shadow, the gull stands out against the background as if it were bouncing off the thick atmosphere.

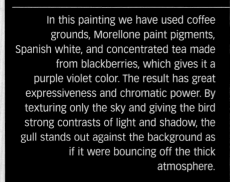

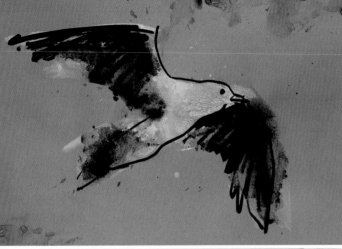

Water and latex applied in puddles is the technique that gives this work random areas of color. This is encouraged by the support of shiny gray primed cardboard. The primer delays the absorption of water for an extended period of time, which causes the dispersion of the pigments, the coffee grounds, and the white pigments in this particular case. The lines were drawn afterward with India ink and a reed pen.

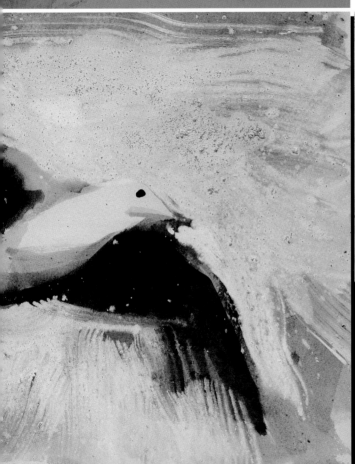

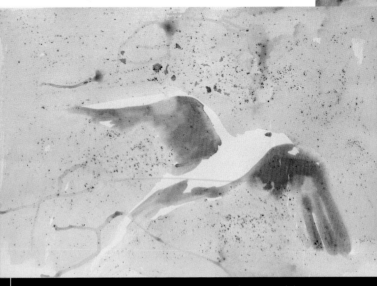

This painting is very simple and required very few materials. It contains iodine, gum lac, and red Chinese tea. There is not a great deal of contrast; therefore, the figure is suggested with a soft and yellowish light.

A fresh and direct painting done with several substances: iodine, gum lac, coffee, Venice red pigment, red tea, and tea made with wild berries. For the background we used a sponge and a synthetic brush for the figure. The orange and violet tones result from the different teas; the yellows, from the iodine; and the earthy red tones, from the coffee and the Italian pigment. Particles of gum lac are visible on the sky.

Here we have extended iodine bound with latex resulting in orange tones over a yellow-paper board. Next, we have drawn the bird's silhouette with agglutinated Morellone pigment to create bright earthy tones. When the paint dried, the sky was covered with a white wash textured with a mixture of Spanish white, coffee grounds, and diluted latex.

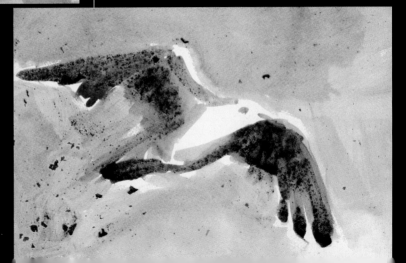

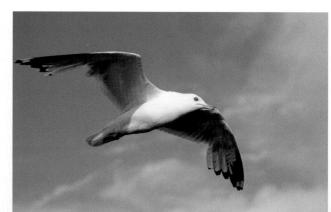

Another point of view To attempt a different approach, the author worked with extreme visual textures that resulted from emulsifying incompatible substances, one oil based and the other water based. When acrylic paints, which are water based, are mixed with an oil-based paint (oils or enamels), they cause bubbles and interesting forms, which can be incorporated artistically. Since it is impossible to bind a water-based glue with an oil-based substance, the emulsion is interrupted, and both substances separate. That emulsion can be dropped into a water tray where the paper, which will be the support for the piece, can be immersed, imprinting on it the whimsical forms.

When the work is dry, it is finished with brush strokes of pigment agglutinated with Morellone paint and Spanish white.

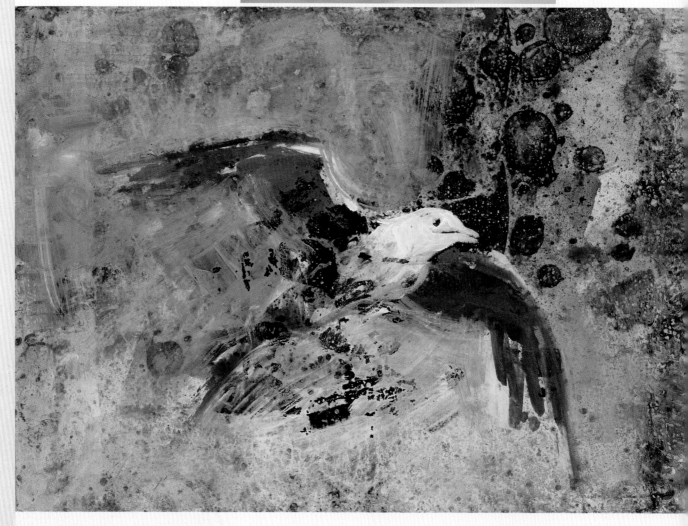

Another model To transition from the sky to the ground, the author chose a different model, a suggestive photograph of his shadow on the road. The texture of the shadows on the ground was created by mixing coffee grounds with Morellone pigment, and the diffused effect of the rest of the sunny areas was painted with tea with mint leaves and Venice red pigment. The result is very poetic because this is a very intangible subject (the shadow) over a subtly textured base.

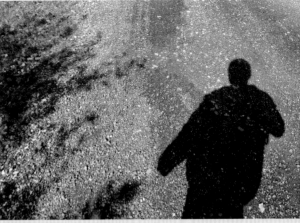

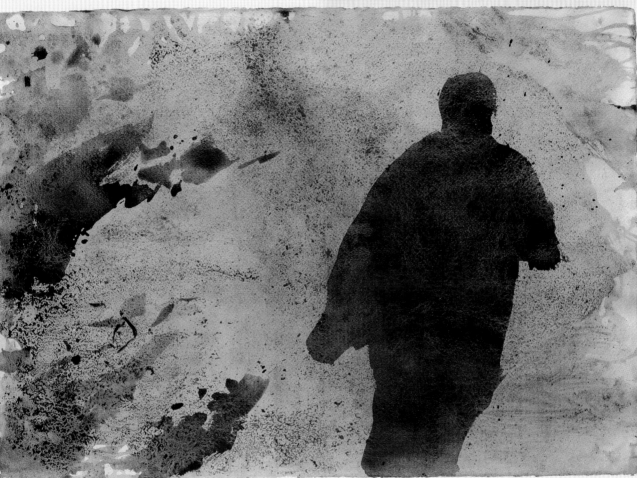

06 Impasto and Relief
Creative Approach

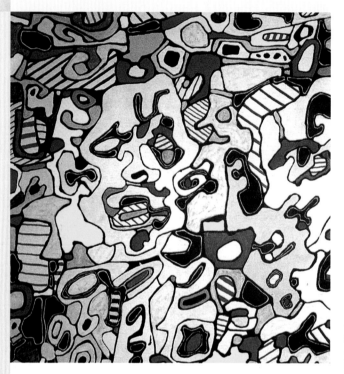

Jean Dubuffet,
Proposiciones amorosas, 1967.
Private collection.

Jean Dubuffet (1901–1985) tried to be trained as a painter several times, but in art schools he did not find creative principles that convinced him, so he dropped out. After that he became involved in the family wine business. It was not until he was 41 years old that he had his first show, at which time he finally decided to devote himself exclusively to art: "I achieved it only after I decided to renounce everything to become an artist above all." He turned his back on the artistic models that were being exhibited in museums and galleries because he found what he was looking for far away from them, in drawings done by children, by people with mental illnesses, and by outcasts, who created their cultural objects using their own resources. This is how he originated Art Brut, in the mid-1940s, which he defined as: "All kinds of pieces with a spontaneous and highly imaginative character." His work ascribes to the Informalist Style, a fusion of Neo-Figurative and textural painting. He looked for unconventional materials like sand, cement, discarded things, which led him to experiment with the new acrylic materials, such as vinyl paint and resin polyester. In 1961, his work ceased to be textural and austere in nature in favor of color and movement. The painting *Proposiciones amorosas* (Amorous Propositions), which was conceived as a visual piece done with thick acrylics, is from this period: "the goal is to gather in a single view several different moments of the view . . . in music this is called polyphony."

Adding Volume and Body to the Painting with Gels

One of the advantages of acrylic paint is that it can be mixed with all kinds of products. In this creative project, Gemma Guasch mixed the paint with different gels and relief pastes to create a dense and textured work in the Dubuffet style. The motif that she has chosen is a still life with tangerines; first, drawn with sgraffito using a pencil, and then, painted with a spatula, a bristle brush, or directly from the tube. For a support she chose a hard and stiff canvas board, which withstands the textural treatment very well. The paint selection is colorist, based on pure and vibrant colors.

" Art has to be born from the material. Every material has its own language, it is a language. "

Jean Dubuffet

Step-by-Step Creations

1. The artist began by painting the background with color that will be used as the base for painting on. On the palette she mixes the acrylic paint, cadmium red, with regular gloss gel to give it more body. This is applied with a wide, flat brush to create a smooth and even background; this way the background acquires volume and warmth.

2. She let the layer of red paint dry and then covered it with white paint—previously mixed with regular gloss gel—which was applied with a wide spatula. This layer was applied liberally leaving the red background exposed on the edges and without smoothing the paint layers.

3. Without waiting for the layer of white paint to dry, she drew the tangerines with sgraffito. The pencil penetrates the white paint—which is still wet—and removes it, exposing the red paint of the background. The pencil tip can be wiped off with a rag.

4. She let the layer of white paint dry and began painting the tangerines, first mixing the lemon yellow, cadmium red, and regular gloss gel on the palette. The resulting color is a bright and thick orange, which was applied with a medium spatula. Next, the volume and the contrast were increased by applying lemon yellow directly from the tube.

5. She continues building the tangerines with abundant paint and different tones. It is not necessary to wait until the paint dries, but it is important not to drag or be too insistent because that would mix the colors. The artist paints the leaves with a small spatula using two shades of dark green mixed with gel; then she contrasts the volume of the tangerines with magenta paint applied directly from the tube.

6. To finish, she paints the other side of the green yellow leaves—mixing lemon yellow and cyan blue—applying it with a small spatula. Then, using white paint directly from the tube, she adds a few areas of light on the tangerines, trying not to mix the colors, because the thickness and tonal contrast are the elements that construct the forms.

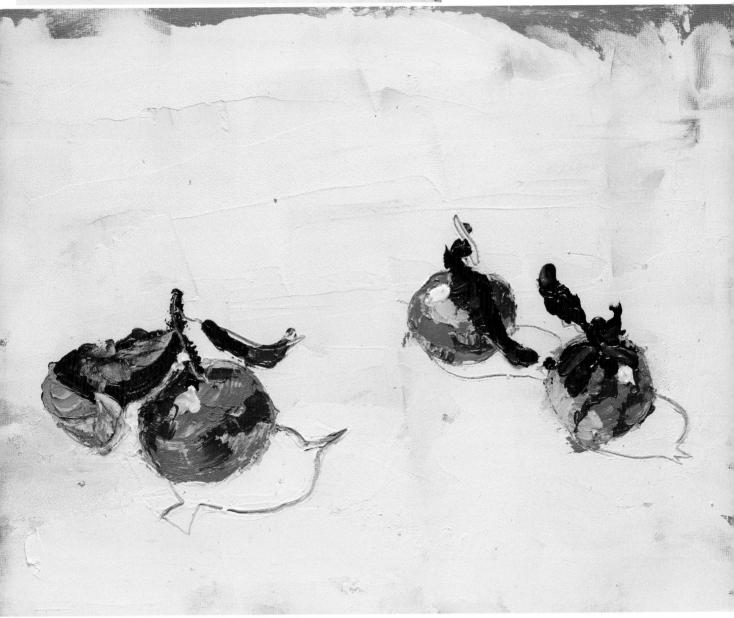

06 Gallery

Other Versions

The gel and the relief pastes, in addition to giving the paint more body, modify its final appearance because they make it more glossy, matte, dense, light, or crackled. If in addition we change the applicator—applying with a brush, spatula, or scraper, or directly from the tube—the results are even more varied and surprising.

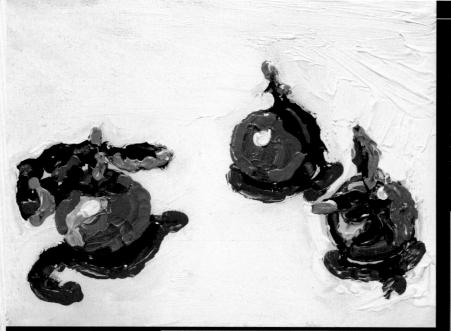

This still life has been painted over recycled board. For the background she has used a narrow, flat bristle brush charged with abundant white paint mixed with thick and matte gel. The tangerines on the other hand, were painted by applying different color paints directly from the tube. In the final work we can see the contrast between the thick and matte background and the creamy and glossy fruits.

In this piece the still life has been painted with the sgraffito technique on a recycled board. The background was painted with acrylic paint, and then a small amount of matte gel was added over it. Then the still life was drawn with a pencil using sgraffito. The finish is subtle and poetic.

A spatula is ideal for applying impastos and thick paint because it responds well when working with large amounts of paint and without retouching the painted lines. This work has been done using only spatulas of various widths. The paint was mixed beforehand with regular gloss gel and applied over a support of recycled cardboard. The final result is fresh, vital, and dynamic.

This time the artist recycled a canvas board and painted the background directly with crackle paint and a scraper. Then, for the tangerines, she mixed crackle paste of different colors, which was applied with different bristle brushes. The crackle paste does not crack immediately but gradually as the paint dries.

06 Window

New
Approaches

Another point of view In all the previous paintings, the gels and the pastes have been mixed beforehand with paint and applied with body and pictorial density. To achieve a different result, Gemma Guasch first painted the background and the tangerines with porous relief paste, and then she modeled each piece with white paste. When the paste was dry, she used very thin acrylic paint (fluids and liquids). The textural result is very different because the acrylic paint acted on the paste as if it were a watercolor, creating suggestive gradations and delicate transparencies.

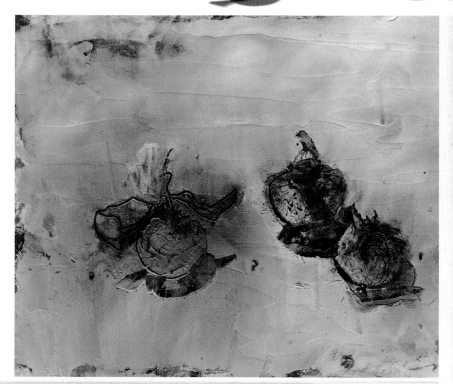

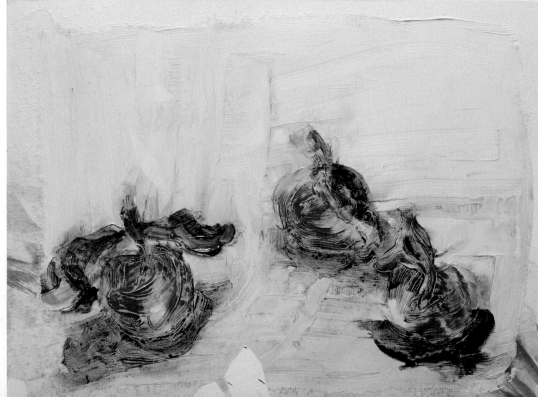

Another model The following model is a cityscape. An image of New York, complex and full of contrasts: among the buildings of new and tall apartments, we can see old factories, fire escapes, and the rooftops with the typical water tanks. The artist has worked with paint mixed with thick gloss gel applied over a board with spatulas of various sizes and also directly from the tube. Then the artist defined the perspective and the different details by drawing the lines in the thick paint with sgraffito. The final result is an urban scene with pictorial density, full of life and color.

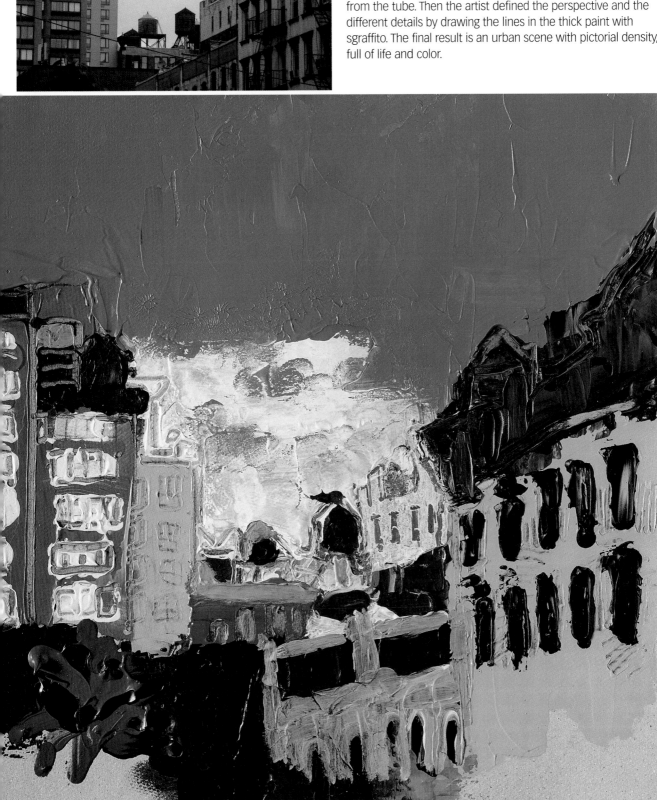

07 Transfer Painting
Creative Approach

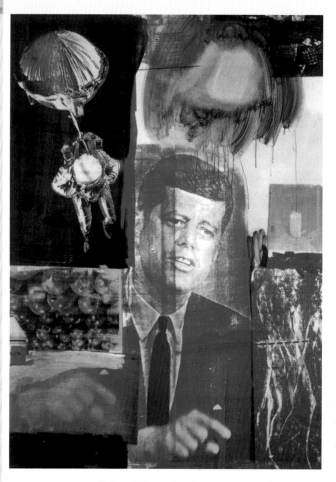

Robert Rauschenberg, *Retroactive I*, 1964.
Wadsworth Atheneum Museum of Art (Hartford, CT).

At the beginning of the twentieth century, Dadaist painters, Surrealists, and Constructivists experimented with collage by integrating images from other sources not connected to art. However, it was during Pop Art in the 1970s that painting fully began to use this method, not just as a contribution as subject matter, but as a technique, which is now known as *transfer painting*. In this sense, Robert Rauschenberg (1925–2008) was the most influential artist using what he called "combined paintings," which consisted of traditional media such as oil or acrylic, as well as collage, assembly, and any "transfer painting" technique. Of his first transfers, completed in 1958, John Gage said, "they are similar to technologies like the television from the same era, but tuned in to a different form." This effect comes from the simultaneousness of images in the same picture, normally framed in box form, like panes in a window, or a monitor, without depth. This simultaneous reading, with no spatial unity or single setting, creates a fluid and timeless space in which object-images flow. To transfer his images over those years, Rauschenberg experimented with emulsions, solvents, gels, and glues of all types, as well as engravings, silkscreen printing, blueprints, photocopies, impressions, and X-rays.

Integrating Photographic Images into the Painting with Transfers

In contrast to Pop Art, the possibilities of transfer painting are greater today due to technological advances. One of the most affordable and simple techniques is the transfer using acrylic gel, which permits the incorporation of photocopies or non-digital prints. Its advantages are the absence of toxicity and easy execution. Its disadvantages are that this technique does not function with photographic copies or digital prints, and it does not permit the use of paper as a support. In this creative approach, Josep Asunción experiments with the method using images in publications from the 1960s and 1970s and a mythical theme: the conquest of space.

❝I felt bombarded by television and magazines, by the excesses of the world. I believed that to carry out a sincere project I should incorporate all of those elements that formed and still form part of reality. ❞

Robert Rauschenberg, 1961.
Art of Montage, a symposium.

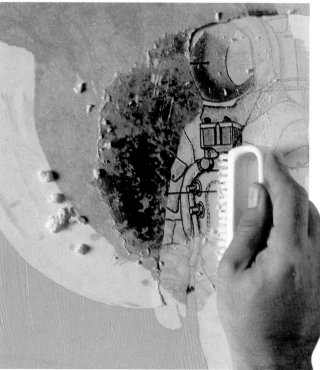

Step-by-Step Creation

1. First prepare the material that will be transferred using photocopies from publications. To get a variety of images, use enlargements and reductions and trim the photocopies to eliminate extra paper.

2. Spread a layer of regular gel colored with yellow acrylic about a millimeter thick over a thin panel, and lay the photocopies over this base. Then let them dry.

3. The next day when the layer of gel is completely dry, wet the photocopies with water to soften the paper. Then remove them using a soft brush or directly with your hands.

4. The image is completely transferred in the gel. We see how it has produced a mirror image, a characteristic of most transfer techniques. We can take advantage of this characteristic or avoid it by photocopying the reverse of the original image.

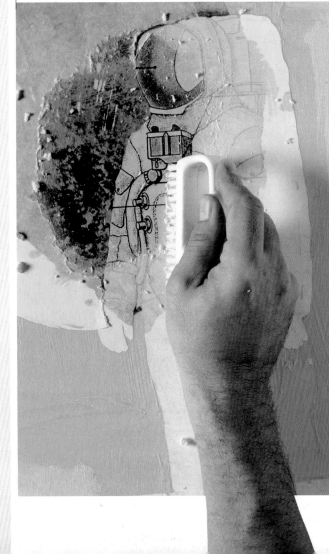

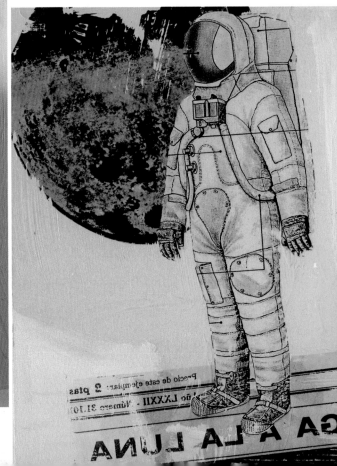

5. The work is continued by painting over the picture. A simple but attractive approach results. Given that the background is yellow, we apply the other two primary colors: blue and red. We place the first brush strokes inside and outside of the figure of the astronaut, in a whimsical form in the Pop style.

6. To conclude, we apply a transparent layer of red to create glazes. To do this, the paint is thinned by 50 percent with a regular gel. With the transparent color, we can color over the transferred image without it disappearing, which integrates it even more into the painting.

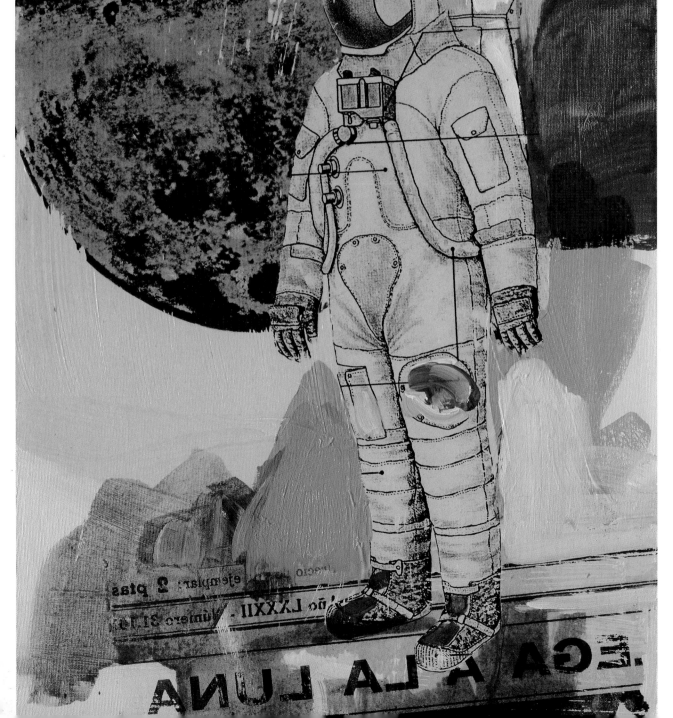

The effect of photographic images and prints combined with paint is fascinating and magical. This dialogue of multiple images and combinations gives us a lot of material to work with, and we can create planes, atmospheres, partitions, and overlapping, such as we can appreciate in this gallery of pieces made with photocopies, in different sizes, of images from publications.

This transfer is made with a slab of wood dyed red. It shows the dialogue between two images at different levels. In one background plane we recognize the transfer of the amplified image from the magazine in black over red. On a primary plane, much brighter and more contrasted, we distinguish a rocket of smaller size transferred by gel colored with white acrylic.

This piece is made with a slab of wood dyed red and was completed in three phases. In the first phase, the images that appear behind the blurred form were transferred with transparent gel. In the second, they were painted with gel and acrylic in white and yellowish tones, and over these thick and fresh brushstrokes are transferred an artificial satellite and a planet. The third phase consisted of concluding the piece with brush strokes of blue acrylic.

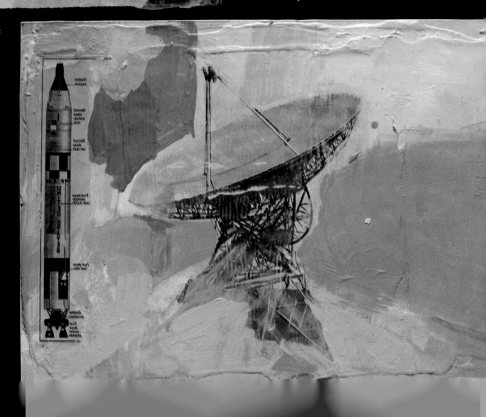

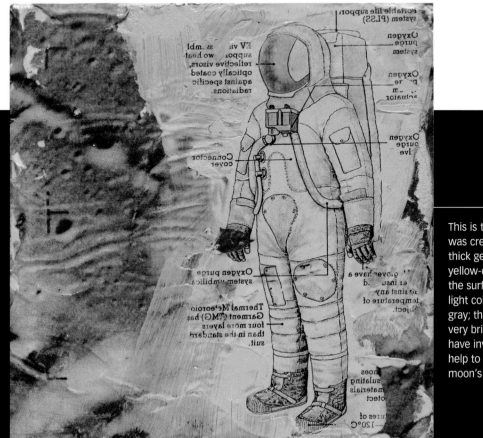

This is the simplest piece in the gallery. It was created on a canvas with a base of thick gel. It has two transfers over the yellow-colored gel: the first, an image of the surface of the moon applied with a light colored gel, creating a sheer pale gray; the second, the astronaut, using a very brightly colored gel. The creases that have involuntarily appeared in the transfer help to create a sense of the terrain of the moon's surface.

Here, we worked on a slab of wood painted with a thick layer of gel and white acrylic. First we made the transfer of a space vehicle in the center of the piece over yellow colored gel. In a second step, it was painted with gel dyed in blue tones and a new transfer of a rocket was made on one side. The final result is both clean and textured.

On a plywood board painted with transparent gel, we created a first transfer: on the left, an artificial satellite over bluish gray-colored gel; on the right, a complex of spatial machinery over transparent gel. In a second phase, we painted with a yellow-colored gel, outlining the contours of the satellite, and over these fresh brush strokes we made a second transfer: a rocket and an astronaut. Some final applications of white provide highlights and glazing in some areas.

07 Window

New
Approaches

Another point of view The transfers made in this project, as well as those of Rauschenberg, function through the combination of simultaneous images that are often compartmentalized in colored planes. For a different point of view, Josep Asunción transferred the images over a single unifying atmospheric background. Since the theme is intimately related with the Cosmos, he created a dark background with particles of light over a metallic copper medium. After a slow and complex painting is made over several work sessions of staining and spattering emulsions with various materials (acrylic and oils, metallic enamels and india ink . . .), a single transfer is made on transparent gel. The final result is dark and dense, atmospheric but with depth, showing a single space scene.

Another model The theme of this project is very narrative (characters, spaces, objects . . .). It offers to establish connections between the transferred images, creating pictorial discourses in these relationships. To finish with a more formal and less discursive work, the artist has chosen an alternative model: a wildflower with an insect sucking pollen. Brush strokes of paint were applied over the transferred image, camouflaging the insect rather than emphasizing it, to center the strength in the rhythm of the petals and the play between the transferred image and the density of the paint.

Creative Approach

Morris Louis (1912–1962), a well-known American Abstract painter, formed part of the Color Field Painting movement along with Kenneth Noland and Helen Frankenthaler. She was the first to develop this approach to color fields, inspired by Pollock's dripped paint and the color washes of Rothko. In 1953, Kenneth Noland and Morris Louis visited his studio and from that moment on they began to apply this technique with personal and different touches: mixing acrylic paint with beeswax and diluting it with mineral spirits, working on cotton canvases without stretching them, and pouring the paint over them and letting it run. He repeated the same process over and over, superimposing layers of color. Finally, he rolled up the dry fabric support as part of the process. In his series *Veils*, the color glazes flow over each other enriching the soft colors. With his experimentation on fabric, Morris provided a new approach for Expressionism.

Morris Louis, *Veils*,
1959. Private Collection.

Experimenting with Acrylics and Fluid Mediums

Gemma Guasch has chosen a photograph of the inside of a lava lamp as the model for an abstract painting based on the creation of viscous and transparent forms. The acrylic paint has been mixed with different mediums (gloss, clear gel, self-leveling, and acrylic varnish), to change the viscosity of the paint. The classic tool—the brush—has been replaced by less conventional applicators. Guasch used a primed cotton canvas for the support.

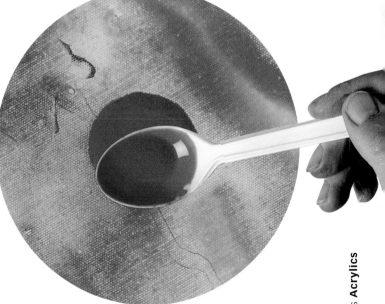

"The value of the work will no longer be found in the completed and perfect finish, but rather on capturing a moment of that experience that is renewed in every piece, not aspiring to universality but focusing on expressing an image of a Unique and intense moment in life. "

Flaminio Gualdoni, *Art, All the Movements of the 20th Century,* 1917.

Creative Techniques **Acrylics**

08

Step-by-Step Creation

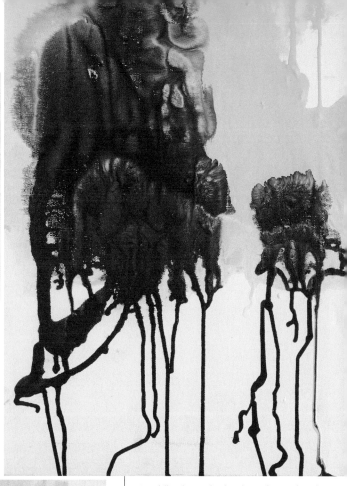

1. Before we begin a project of this kind, it is important to keep in mind that the canvas will be placed in different positions depending on the desired effects. Sometimes it will be vertical and others flat, so it is not a good idea to paint on an easel. The artist begins by splashing a mixture of yellow and white paint mixed with a gloss medium on the canvas.

2. While she waits for the paint to dry, she mixes red paint with gloss medium in a can. She tilts the canvas and splashes the paint on it directly from the can, letting it drip down the canvas. Next, she sprays it with acrylic varnish, which creates forms that are rounded and more transparent.

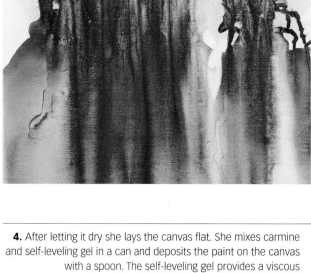

3. The previous step produced too many droplets. To correct that, and to create a subtle and suggestive glaze, the artist tilts the canvas and splashes medium from the middle down. This makes the layer of red paint spread as it becomes thinner, which creates different shades of red that are more subtle and interesting.

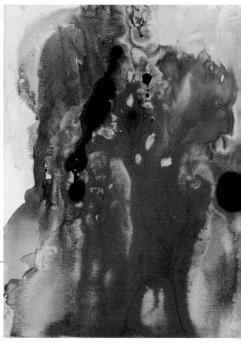

4. After letting it dry she lays the canvas flat. She mixes carmine and self-leveling gel in a can and deposits the paint on the canvas with a spoon. The self-leveling gel provides a viscous finish and makes the splashes of paint dry evenly and without changing.

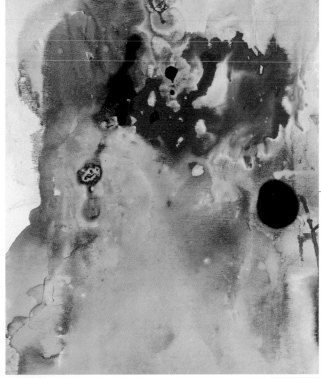

5. Now, she dilutes the yellow paint in a large amount of water and a small amount of medium to apply a very thin glaze over the other reds.

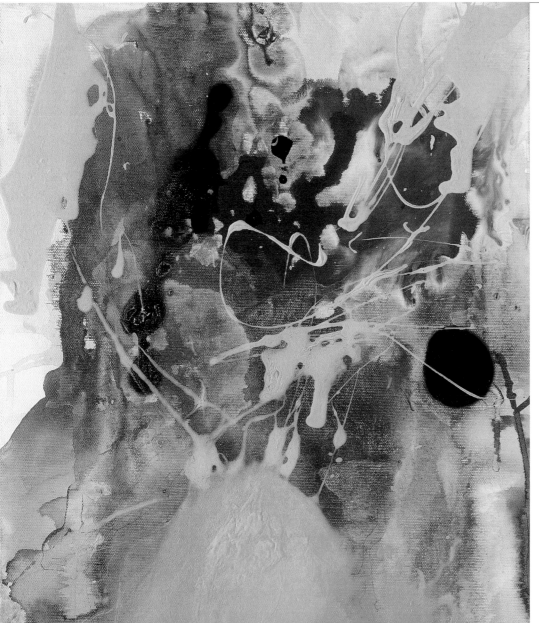

6. To finish, she mixes different yellows and white with clear gel in a can. First, she lays the canvas flat; then, using a brush or a spatula, she lets the paint drip on the canvas and, finally, she moves the canvas to cause the liquid to run. The clear gel changes the consistency of the paint and makes it runny to create the dripping effect.

08 Gallery

Other Versions

Paintings made with glazing and fluids are attractive and different. First, because acrylic paint can be mixed with many products, this encourages a great deal of experimentation. Second, when applied in unconventional ways, the results are far from the typical stereotypes and thus more creative. Using these two premises, Gemma Guasch has approached this gallery with enthusiasm.

The canvas was kept flat on the surface at all times. Every color was mixed in a can with self-leveling gel and then splashed over the canvas, letting it create spontaneous forms. The self-leveling gel gives the painting a thick, viscous, and smooth finish.

This exquisite and subtle glazing has been painted on wood. The artist mixed a generous amount of paint with a medium and spread it to create very thin layers.

This work was painted on a canvas board placed vertically to allow the paint to run downward. To apply the different layers of paint, the artist first splashed it on the board, and then she splashed medium over it to make it more fluid, and then acrylic varnish to make it run, which exposes the previous layer of paint.

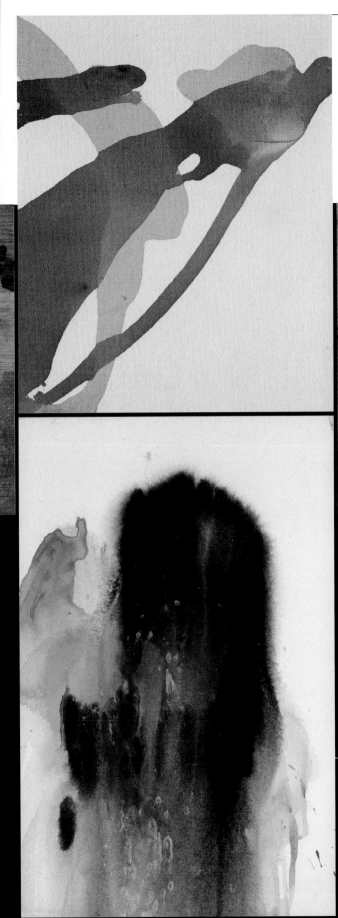

This is the most direct and fresh piece in the gallery. Here, the paint was diluted with water and allowed to run by moving the canvas with the hands. The orange tones were left to dry before applying the red colors to avoid losing the sharpness and transparency.

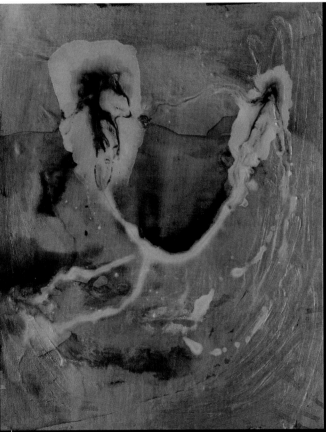

This time, the artist painted on recycled canvas. The density of the paint made it possible to appreciate the thickness and texture of the glaze and the areas of fluid paint. The final result is more viscous and thick than the rest.

The next painting was done on cotton canvas. To change the intensity of the paint, the artist tilted the canvas slightly, allowing the glaze to form gradations. The final result is airy, subtle, and suggestive.

Creative Techniques **Acrylics**

08 Window

New
Approaches

Another point of view To create another approach without losing the innate quality of glazes, we have changed the support. This time the support has not been primed and consists of a cotton canvas and handmade paper. Since they have not been primed, they absorb the paint, which dries very quickly making it very easy to layer colors, but it does not allow corrections. The first painting, done on cotton canvas without priming, shows each layer of paint very well because the rapid absorption by the canvas favors transparencies. In the second piece, painted on paper, the effect is similar but less extreme because the dark layer partially covers the previous layers.

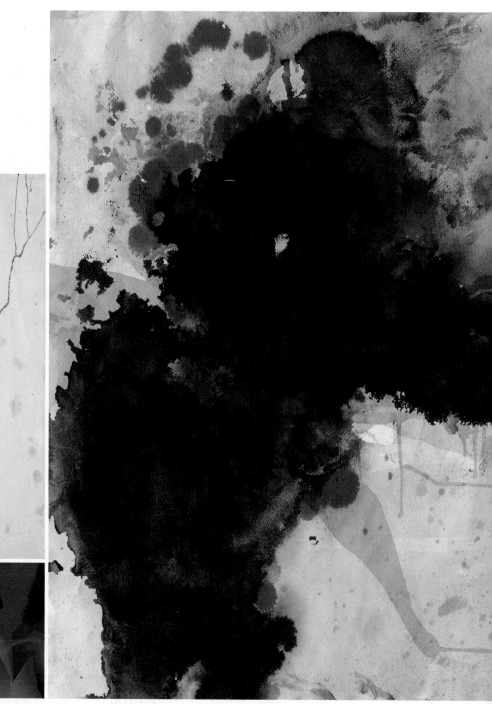

Another model This time the author has chosen a photograph with some level of abstraction, the out-of-focus light of fireworks. The abstraction was possible because the photograph was manipulated by capturing the scene with a lens out of focus. The effect of this photograph is very different from the previous model, the lava from a lamp, because the light is completely circular, static, and ethereal. For this work we have used a heavy handmade paper where we previously painted a few thick and textured areas of color, followed by delicate, fine, and thin glazes.

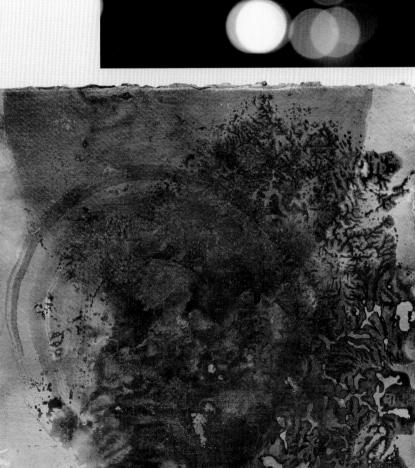

Creative Approach

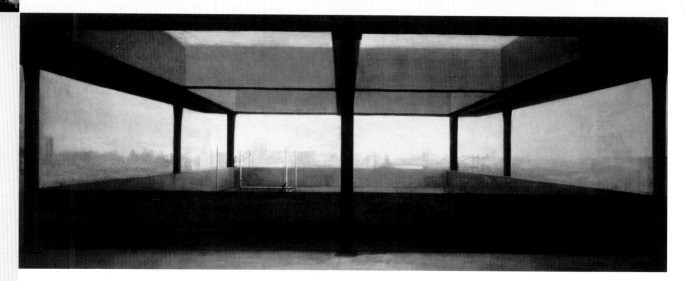

José Manuel Ballester, *Patio Interior,* 1997. Private collection.

The austere and often monochromatic value-based chiaroscuros of certain Baroque, Neoclassic, and Realist paintings show that a painting can inspire deep emotions without using color. A contemporary artist who can stir that esthetic emotion is the Spanish José Manuel Ballester (born in 1960). Following in the footsteps of predecessors such as Edward Hopper (1882–1967) and Vilhelm Hammershoi (1864–1916), he tries to instill, in his own words, "emotions and even the human condition itself by selecting certain spaces, made up spaces, artificial landscapes after all." But, unlike Hopper and Hammershoi, Ballester does not include people in his spaces; he presents stages that are temporarily empty, spatial structures that have basic compositions but are striking and empty, where human presence is suggested by the halo of their absence. His work is half way between photography and painting, it can be considered a photograph made with paint or a painting captured with a camera. He alternates both media at will, often combining them together in a new photographic "pictorialism" when he finishes some of his large photographs with acrylic paint. The huge canvas *Patio Interior*, done with grisaille shadows using white and black acrylic paint, is reminiscent of a Last Supper from the Renaissance period, but without the figures.

Painting with the Tones of the Monochromatic Ranges

Acrylic paints are associated with colorful paintings because they were originally used on murals and Pop Art, but in reality they are an ideal medium for monochromatic applications. Their quick drying time makes it possible to create washes and layered impastos, creating expressive chiaroscuros with modeling and glazing. In this project, Josep Asunción plans to use grisaille to paint dark and light contrasts for clouds, using color sparingly. He uses the various acrylic formats—liquid, fluid, and thick—always in a gray color range with a blue base. The artist uses small and large brushes on canvas boards.

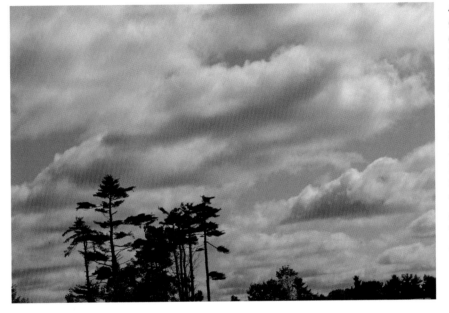

❝I want to show that behind all this front, this jungle of connections, and this swarm of telecommunications, in the end you cannot avoid but to look at yourself in the mirror of your loneliness, to set out to get to know yourself and who you are. ❞

José Manuel Ballester, 1999

Step-by-Step Creation

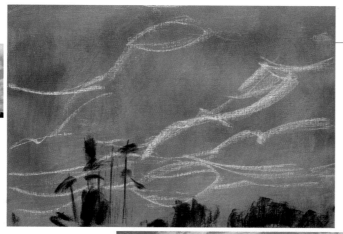

1. The sky of this landscape is white, black, and blue, so the artist will apply the grisaille on a blue gray background, which will be the overall color of the painting. When the background is dry, he blocks in the drawing with gestural movements using chalk and charcoal, two media that are easy to erase.

2. The first colors are of diluted white acrylic paint, and they will represent the light of the clouds. At this point, the layer of paint is thin and wet, so it dries quickly and does not become overpowering.

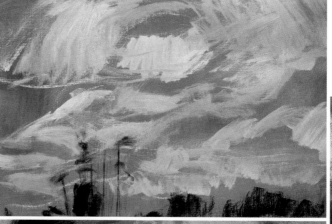

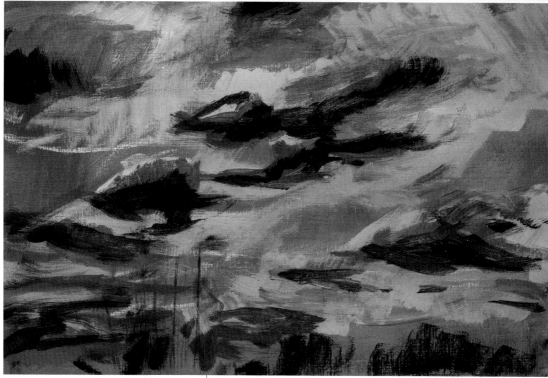

3. After they dry, he paints the gray color of the sky with fresh and thicker paint that will be blended later when he does the lines. Using a round bristle brush he applies two values of gray: one medium and one dark.

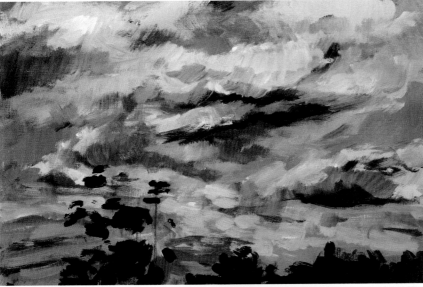

4. The artist finishes the white sky quickly, while the gray colors are still wet; this time the thick paint creates blends and impastos. Next, the trees that had been drawn at the beginning with charcoal are painted with blue black, leaving the final touching up of forms and highlights for the end. He uses a filbert bristle brush to do this.

5. Finally, he defines the tree lines with blue black and a wide bristle brush without too much paint. He has tested the brush strokes on a piece of scrap paper to accurately recreate the foliage of the fir trees. This way, he will make sure that the amount of paint and the movement of the brush are correct.

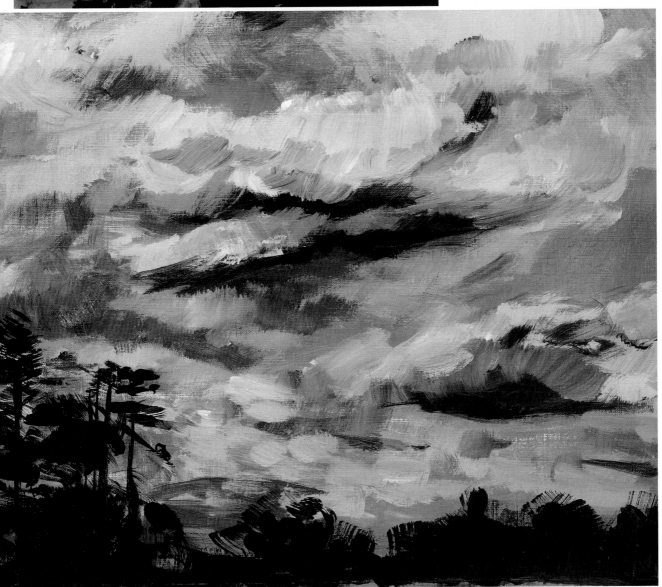

Creative Techniques **Acrylics**

09 Gallery

Other Versions

In this gallery we appreciate how acrylic paint can be used to create very different grisaille styles with fresh and natural results. The artist has changed the density of the paint to create either very liquid or very thick effects without altering the overall tones.

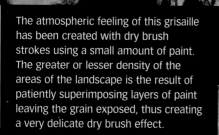

The atmospheric feeling of this grisaille has been created with dry brush strokes using a small amount of paint. The greater or lesser density of the areas of the landscape is the result of patiently superimposing layers of paint leaving the grain exposed, thus creating a very delicate dry brush effect.

An expressive grisaille was painted with very diluted acrylic on a canvas primed with warm gray tinted gesso. The luminous and transparent atmosphere was created with glazing and puddles, and the overall light was strengthened by adding contrast and tension with the black of the trees.

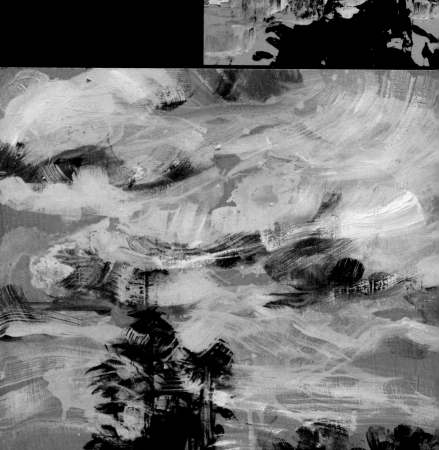

This is the foggiest and most atmospheric version in the gallery. By using very thick and dense brush strokes and a round brush, the artist has created a very dense feeling in the air. To complete this phase of heavy paintings, the trees have been painted using the color directly from the tube.

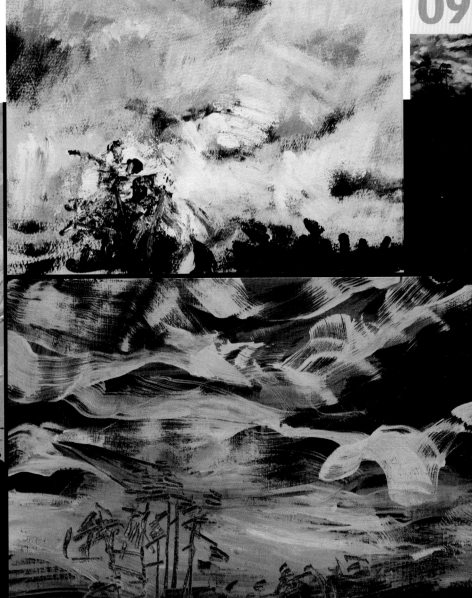

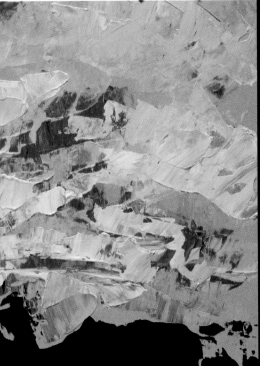

Landscape done with a spatula on a heavy neutral-gray board. The acrylic paints, which have been applied thick, have been gradually blended wet on wet to create interesting effects during the mixing process. The final result is very clear and expressive yet dynamic and fluid.

This painting, which looks ethereal and mysterious, has been painted over a black background. A fan-shaped brush was used to apply thin brush strokes of white paint to create areas of light on the sky, and sgraffito made with a spatula defines the vegetation.

09 Window

New
Approaches

A different point of view Without departing too much from grisaille, Josep Asunción has tackled the same landscape in a very different way, ignoring the logical scale of the gray colors. To achieve this, he has inverted the image, as if it were a photographic negative, while maintaining the pictorial and gestural styles. In the resulting painting, the gray values are opposite those of the landscape: the blues are oranges (its complementary color), the light areas are now shadows, and black is white. This is a visual play that results in an interesting and strange image, with a dreamlike fantasy atmosphere, that is far from realistic.

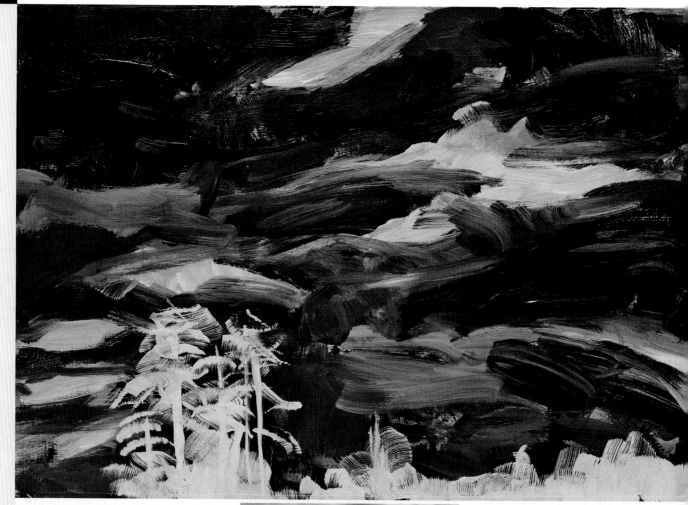

Another model Since the landscape with clouds drew all its expressive power from the contrasts of the sky's chiaroscuro modeling, the author chose a different model for an ethereal and spatial scene, with fewer volumes: a sunset that captures our attention with its visual and chromatic sharpness. The final result is a calm and smooth grisaille where the artist neutralized the color to make the contrast more luminous and less chromatic. This way the sunset becomes a quiet and contemplative image, unlike many other similar scenes.

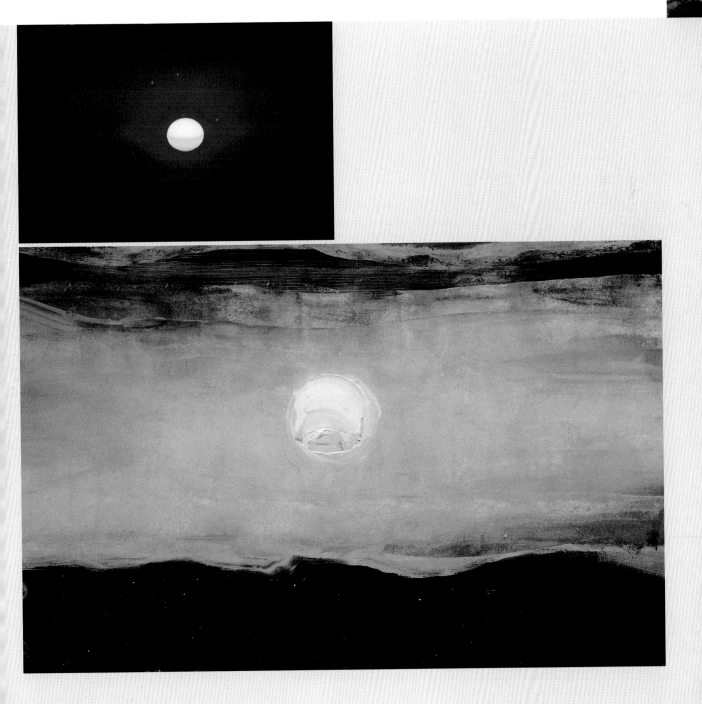

10 Washing
Creative Approach

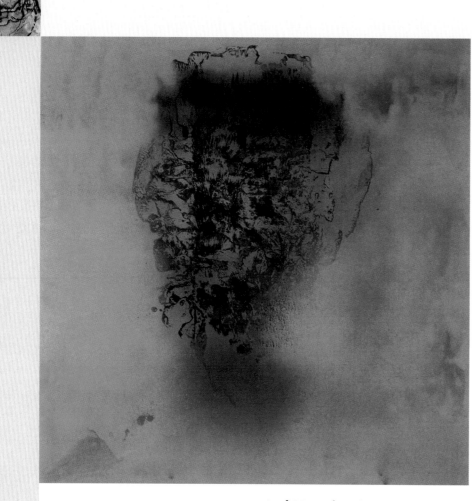

José Manuel Broto, *Los pasos V,* 1994.
Private collection.

Poetry and painting are two elements that define the work of Spanish painter José Manuel Broto (born in 1949). He began his artistic career during the 1970s when he founded the group Trama with the support of Antoni Tàpies and Galería Maeght. During this period he became involved in the Neo-Abstract current influenced by the esthetic principles of the French group Support(s)-Surface(s). Little by little, his work evolved into a gestural, lyrical, and colorist abstraction. The color and its gestural quality became more important, and this gave his paintings emotion and expressiveness, as well as power and tension. In his later paintings, he used very thin washes of acrylic paint and various tars, thus creating empty and contemplative spaces that resemble Chinese poetry and the work of Spanish mystic Saint John of the Cross. In his work entitled *Los pasos V*, the paint is diluted, and it transforms until it becomes almost immaterial, forming beautiful light halos.

Discover the Effects Produced by Water on Wet Acrylics

Acrylic paints are a very versatile and durable medium that is ideal for painting freely and without limits. A technique as direct and aggressive as washing produces very interesting and surprising results. This technique consists of removing paint by applying diluents directly on it—in this case water—and then drying it with a hair drier or a rag. The subjects that Gemma Guasch has chosen for this exercise are several seashells of various shapes. She has used a cotton canvas as a support, and finally, she selected very unconventional applicators such as sponges, paint rollers, rags, and a shower handle to spray the water directly on the painting.

"In the same line as this apparent humbleness, which treats emptiness with plenty, is where we would place a fragmented piece or an offset figure as the only possible sign of totality."

José Ángel Valente,
Elogio del calígrafo, 1977.

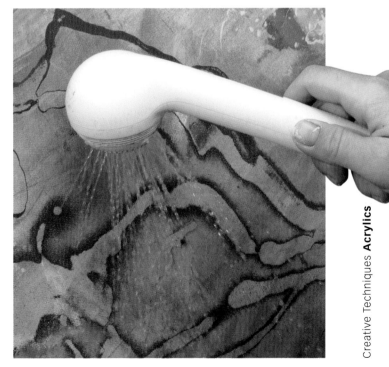

Creative Techniques **Acrylics**

Step-by-Step Creation

1. The first step is to prepare a good background. For this, Guasch applies the washing technique with the support laying flat. A water source and a container with a drain (bathtub, sink, or a tub) are required. She applies the paint liberally on the canvas, which is left to dry a little bit, and then she runs the water directly over the paint, finally drying it with a rag. This process is repeated several times, and changes the ultramarine blue color, as well as the light pink and the blue green. Once dry, she draws the outlines of the seashells with light pink using a paint roller.

2. Next, she dilutes burnt sienna in a container, and with a thin brush charged with a large amount of paint applies the outlines of the seashells by dripping the paint from the brush held a short distance above the surface.

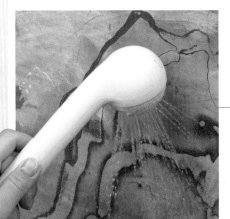

3. It is allowed to dry for a short period of time and then the seashell is washed directly with the running water from the shower head at low setting, holding it as close as possible to the painting. The washing produces a hollow or empty line in the middle but it does not affect the edges, which stay the same.

4. The excess water is removed with a rag. Next, we paint another seashell with thick impastos, using a hard bristle brush.

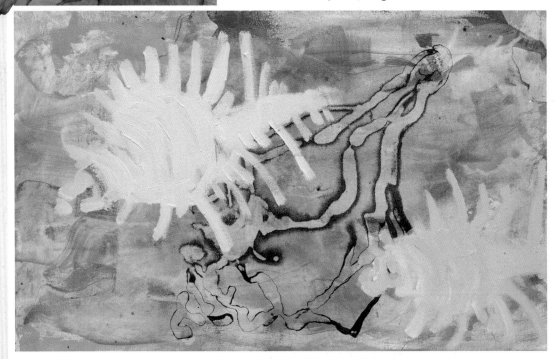

5. Next, the washing technique is repeated. This time, since the seashells have been painted with a large amount of paint, we let them dry longer.

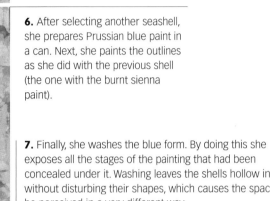

6. After selecting another seashell, she prepares Prussian blue paint in a can. Next, she paints the outlines as she did with the previous shell (the one with the burnt sienna paint).

7. Finally, she washes the blue form. By doing this she exposes all the stages of the painting that had been concealed under it. Washing leaves the shells hollow inside without disturbing their shapes, which causes the space to be perceived in a very different way.

Other Versions

Without changing the support but changing the applicators and the way the washing technique is applied, Gemma Guasch has done several additional interpretations of the seashells. In doing so, she has created a rich and diverse gallery that includes a few atmospheric, dense, and subtle finishes and others that are strong and direct.

In this painting the forms are intertwined, which creates a warm atmosphere. The artist has used sponges, as well as different size brushes; only some of the areas and some of the forms have been treated with the washing technique. The result is fresh and subtle.

In this painting the artist has done multiple washing applications and has used multiple applicators. First, she painted the background using a wide brush, a paint roller, and a rag. Over that she painted the seashell with a large amount of paint, after which the piece was left to dry for some time. Next, she has washed it partially to avoid duplicating effects. This washing has created two distinct planes: the seashell in the foreground and behind it the background.

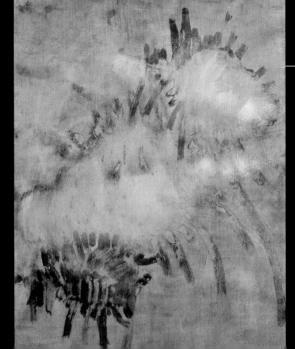

This time the artist has done the washing first, directly under the shower with the pressure set quite high, and then by hand with a sponge. By doing this she has combined strength and subtlety. The white atmosphere softens the hardest forms, blurring them.

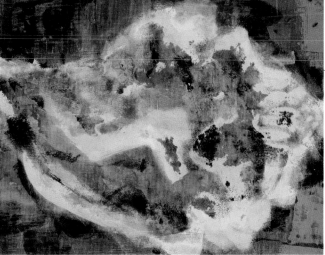

In this painting, the artist has not applied the washing technique directly. She has used a paint roller instead, first on the background, and then over the outlines of the seashell. The hollow areas that are formed inside of it result from passing the roller several times over it. The final painting is airy, soft, and atmospheric.

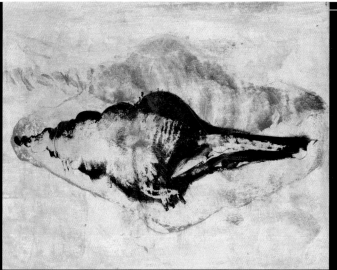

Applying the washing technique directly produces striking and extreme results. In this instance, the seashells are clearly visible. The water, as it runs, leaves a trace behind, which instead of concealing it, was used by the artist to make a powerful statement.

To obtain different results, the artist has used different washing techniques on the same form. She has used a rag, a sponge, a paint roller, and finally a good wash with power and pressure. Here, the seashell shows a heavy concentration of paint in the central area.

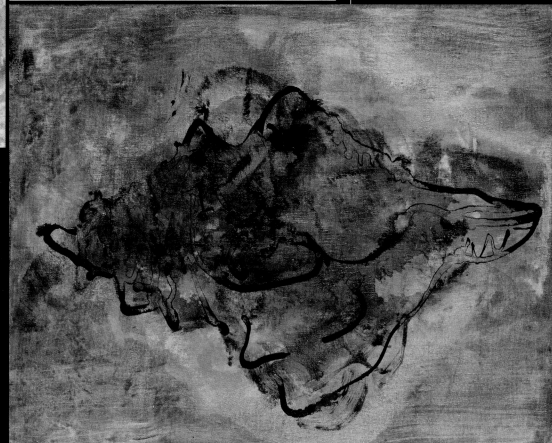

Creative Techniques **Acrylics**

10 Window

New
Approaches

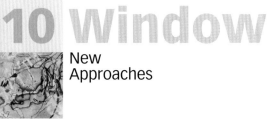

Another point of view The approach to this washing technique is different from the rest of the projects because instead of having a defined shape, it has an overall abstract feeling. Using the washing technique for abstract paintings is a dangerous undertaking because the lack of defined outlines runs the risk of creating a chaotic scene. In the first project, the atmosphere covers the painting in a subtle way; in the second, a thin grid gives way to a rich and deep space.

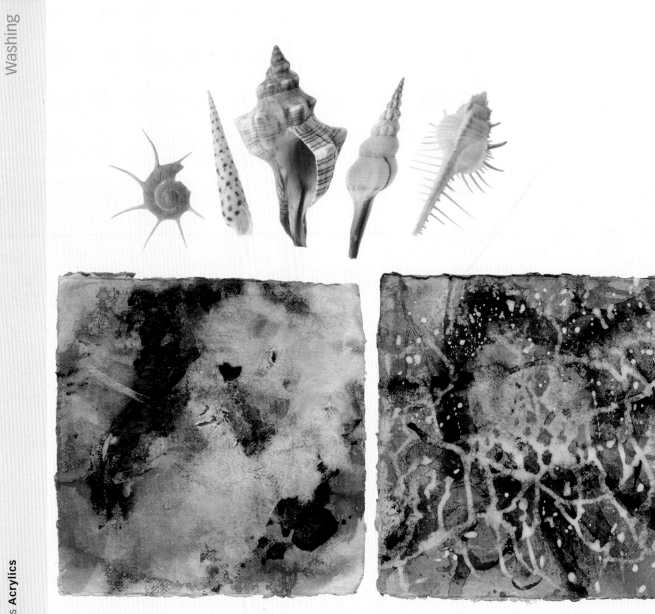

Another model Sometimes, nature offers views that are an invitation for the washing technique, like this marshy landscape. It is a theme with few details and a very natural feeling, very appropriate for this technique. The artist has worked on a canvas board, first with a paint roller, sponge, and a rag, and then she has washed the lines where she wanted to create hollow areas with high pressure. The results are simple, clear, and direct.

10

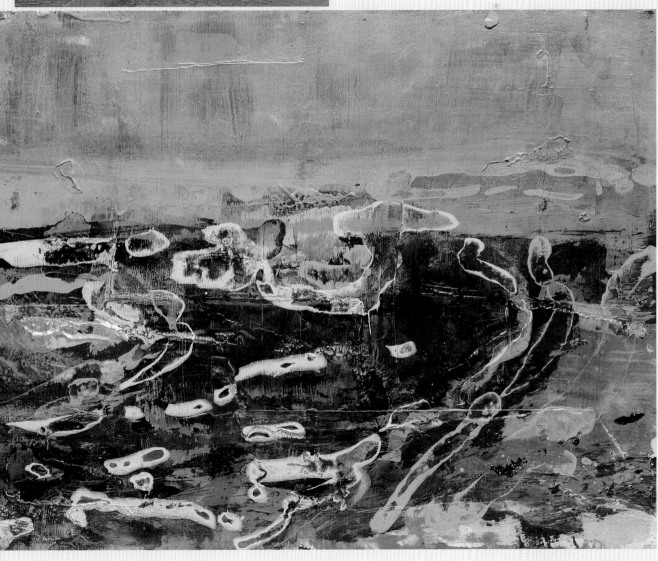

11 Gestural Painting

Creative Approach

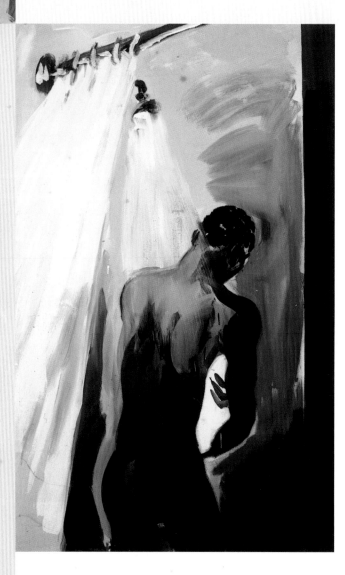

During the 1980s German painting experienced an important resurgence that reached the levels of previous European movements like the Expressionism and Neo-Expressionism (the Cobra group). Rainer Fetting (born in 1949), one of the main exponents of the Neo-Expressionist group in Berlin, created interesting large acrylic paintings with a fresh and direct gestural language, like his magnificent series of shower paintings. His paintings are related to his personal life: cityscapes from Berlin and New York (the two cities where he lived), portraits, self-portraits, and nudes. His city themes are focused on marginal and sad neighborhoods, subway stations, and alternative lifestyles. His method of work is pure action painting; he always avoided touching up his paintings to maintain the freshness of the image. He paints in stages, at extreme speeds, as if he were interpreting a piece of rock music. In fact, he has played in a few rock bands, which is characteristic of the Germans of his generation, a group that not only had age in common, but also a lifestyle and certain esthetic views. The colors of his paintings are somber and elaborated, and the figures are stylized and contort to the rhythm of the gestural movement of the paint strokes. His painting style, as that of others of his time, could be seen as "careless" or "lacking virtue," but in reality Fetting maintains absolute control of the work when he paints.

Rainer Fetting,
Man Under Shower, IV, 1981–1982.
Private collection.

Directly Applying Free and Expressive Brush Strokes

German Neo-Expressionist painters adopted acrylic paints right away because of their immediacy and the showy results that could be created with them. Since acrylics dry quickly, they are ideal for quick gestural and direct brush strokes. In this approach, Josep Asunción has created a series of gestural portraits of a male model. For the support he has chosen round, high-quality, and heavy cotton papers. This special format, known as "tondo," highlights the movement of the model and the gestural strokes.

"A new freedom is born thanks to which human beings will be able to express themselves as their instinct dictates (. . .) our art is inscribed in a period of revolutionary transformation: it is a reaction against a world that is disappearing and, at the same time, the precursor of the new one that is emerging."

Constant Nieuwenhuys, *Cobra Manifesto,* 1948.

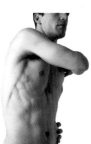

1. From the first sketched lines of the painting, the artist focused all the energy on the brush strokes. Technically speaking, using a round brush he approached the work deliberately, but vigorously, to prevent the brush strokes from appearing tentative, insecure, or mechanical. It is important to practice on scrap paper until the shape of the figure is clearly visualized so as to approach it with confidence.

2. Before adding volume to the figure, the artist painted the background. The brush strokes are wide because they have been painted with a wide brush. The colors of the background are cold to create a vibrant contrast against the warm colors of the figure.

3. Next, the shadows on the torso are defined with quick and vigorous brush strokes, using very diluted violet color. Over that the artist has applied a luminous yellow green, as a transparent wash.

4. The rest of the skin is finished with orange and violet brush strokes, which are applied with a flat brush, leaving the white of the paper exposed in the areas where he wished to preserve the most light. To recuperate the contrast between the background and the figure, the artist redraws the silhouette with black paint applying a clean and fluid brush stroke with a round brush heavily charged with paint.

5. The overall tone of the painting is darker than desired, therefore the artist has decided to apply a few wide and very direct brush strokes over the green background. He uses a large brush fully charged with paint. The drips that are splashed in the process increase the feeling of directness and quickness of the brush stroke, a very characteristic approach of gestural expressionism.

11

Maintaining the "tondo" format of the project, the artist has created different versions of the same torso experimenting with different types of strokes in each case. He has approached all of them directly and vigorously, by changing the speed, the amount of paint, and the brush.

In this dynamic but well-balanced figure, the artist has painted with gestural strokes but not very fast, using a wide bristle brush and a small amount of paint, which produces transparencies and subtle effects. To make the acrylic paint flow faster, the artist has covered the background with yellow acrylic paint.

The sculptural feeling of this torso has been achieved with short and quick strokes of the brush. Each gestural stroke is the result of changing the angle of the wide brush as it slides down the paper. Rotating the brush changes the shape of the stroke thus preventing the painting from looking monotonous.

This painting has been done very quickly, without touching up and without too much reflection. The result is more disproportionate and wild, along the lines of the German Neo-Expressionists. The brushes used were round and charged with a large amount of paint.

The wide strokes of this painting have been applied with a large brush, and the sinuous ones with a round, fine tip brush. It would be very difficult to achieve a clean and firm gestural line without this brush. The variations in thickness of the sinuous lines are the result of the pressure applied on the paper with the brush: the greater the pressure, the thicker the line; the lighter the pressure, the thinner the line.

This painting is quite elaborate because it has several layers of paint on the background and on the mass of the figure. When the layers are dry, the figure is finished using a direct approach, painting the contours with a round brush, heavily charged with black acrylic paint mixed with clear gel. The final touches have been added with brush strokes that leave lines and drips, which is why the approach has to be very quick and decisive.

Creative Techniques **Acrylics**

11 Window

New
Approaches

Another point of view In keeping with the Expressionist and gestural spirit of the project, Josep Asunción wanted to do a few paintings with a minimalistic approach, to maximize the beauty and visual simplicity of the theme. In one of them he has reduced the figure to two colors: red for the forms and the white of the paper for the light. In the other painting, he has achieved simplicity using lines. On a background painted with acrylic yellow paint he has drawn the silhouette with a bristle brush and black acrylic mixed with clear gel. The magic of this image resides in the sharpness of the sinuous and direct line, without any touching up.

Another model A still life full of fruits and vegetables is the perfect theme for gestural painting, as can be seen in this work. In keeping with the circular format, Josep Asunción has defined each vegetable with a gestural brush stroke, directly and vigorously. To be able to paint with confidence, the artist has first identified the placement of each piece. In doing this he was able to enjoy painting and to focus on selecting the colors, the brushes, the amount of paint needed, and the final touch of energy, without worrying about the proportions. The result is lively and expressive.

12 Reserves

Creative Approach

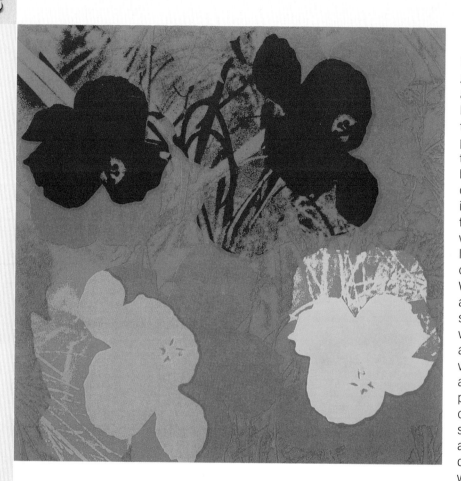

Andy Warhol, *Flowers*, 1970.

During the latter part of the 1950s, Pop Art (popular art) emerged in England and in the Untied States. Its origins are based on the principles of Dadaism, but this movement rejects all the anti-art philosophy of Dada. Pop Art does not think of art as a unique and single piece but as work in series. Its icons are consumer products and capitalism, and its followers are the masses. The most famous exponent of American Pop Art was Andy Warhol (1928–1987), who was labeled by Brett Gorvy as "the Picasso of the latter part of the 20th century." Warhol began as a magazine and advertising illustrator and had some success, but what made him famous worldwide was his work as a painter and avant-garde cinematographer. In his work he tried to erase any trace of the artist's hand, which is why he started by projecting photographs directly on the canvas and later began using serigraphs. His idea was to produce artwork in series, minimizing his creative role in the production of his work, which made him popular but controversial at the same time. He created several pieces that became 20th century icons, like the Campbell's soup cans, the Coca-Cola bottles, and the portraits of popular people like Marilyn Monroe and Mao Tse-tung. In 1963, he founded his famous studio The Factory, which became an important gathering place for New Yorkers. He made more than 900 serigraphy copies of his painting *Flowers* in sets of ten with a printing run of 250 sets, numbered and signed. This is how he achieved his goal, of producing artwork in series.

Using Stencils to Paint Compositions with Areas of Color

Sometimes artists may want to reserve or protect a part of a painting by covering that particular area. This type of work must be planned carefully by studying the model, deciding what parts are to be reserved, and choosing the reserve method (stencils, adhesive tape, masking substances, or wax). For this project Gemma Guasch has planned a painting with stencils, for which she has made several cutouts on regular paper of the areas of the model that she wants to protect. The model that she has chosen is a bouquet of beautiful flowers, which she will paint on handmade paper. The artist uses a variety of tools for applying the paint such as sponges, synthetic hair brushes, and gauze.

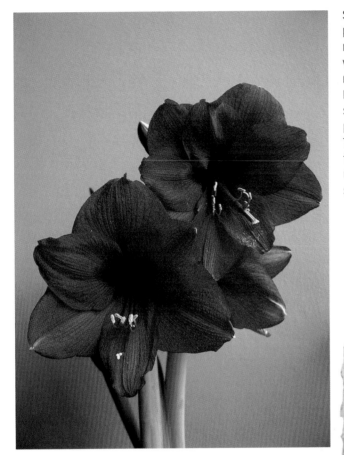

Every painting is a fact: paintings are charged with their own presence.

Andy Warhol

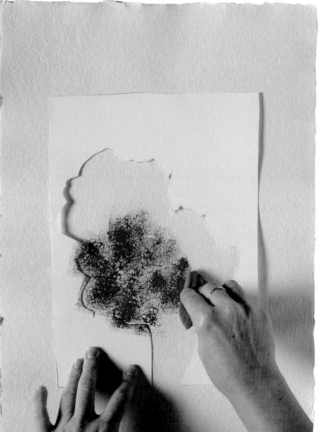

Step-by-Step Creation

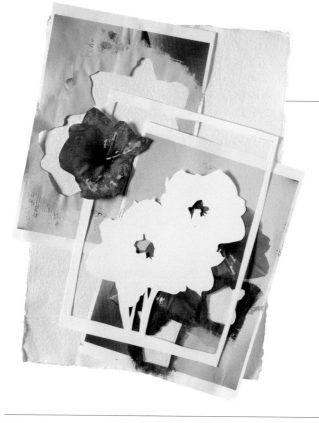

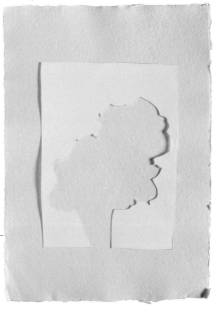

1. Before painting, Gemma Guasch draws and cuts out the stencils that will be needed. She has made a few positive stencils (flowers), and a few negative ones (background).

2. She places the stencils on the paper securing them with adhesive tape or holding them down by hand to prevent them from moving. Once the model is well protected, she begins to paint the empty space outlined by the stencil.

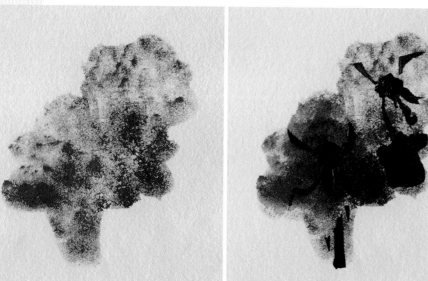

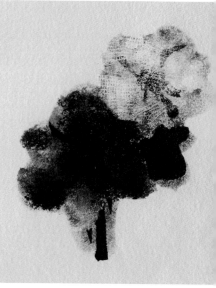

3. Working dry, she applies quinacridone red with an unmoistened synthetic sponge. She paints the empty space and then removes the stencil. By working dry on dry, the artist has produced a very creative, porous, and uneven layer of thick paint. The selected stencil, being a negative of the model, has protected the background and has outlined the silhouette of the flowers with precision.

4. With the first stencil she has outlined the three flowers as one. Now, she is going to define them separately using another stencil and filling the inside of each flower. To cover it completely, she applies quinacridone red with a narrow synthetic brush.

5. She paints each flower differently to set them apart, using a unique stencil for each. For the flower on the left, she applied dark quinacridone orange with a round bristle brush. For the one on the right, she used white paint and a piece of gauze. Both flowers were painted dry, without using water.

6. Each flower will be further defined, this time the interiors. She protects the petals with a stencil and continues by painting the inside with a narrow bristle brush: the flower on the left with white and the one on the right with crimson. Then she defines the flower and the petal on the right with white paint applied with a dry sponge, to avoid covering the previous layers with paint.

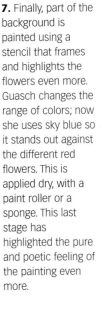

7. Finally, part of the background is painted using a stencil that frames and highlights the flowers even more. Guasch changes the range of colors; now she uses sky blue so it stands out against the different red flowers. This is applied dry, with a paint roller or a sponge. This last stage has highlighted the pure and poetic feeling of the painting even more.

Creative Techniques **Acrylics**

Other Versions

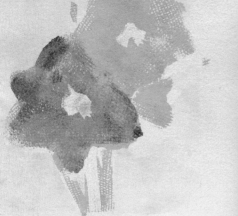

When working with reserves, the shapes can be appreciated either in the negative spaces, masking the shape and only painting around it, or through their imprint—painting the shape to reveal the positive. This is a very creative and experimental technique that Gemma Guasch used to produce attractive and diverse results.

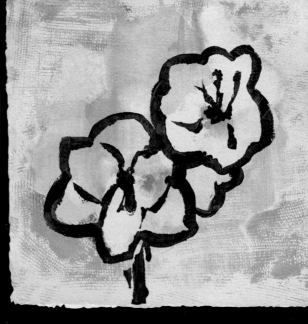

This is the most direct and contrasting work of the gallery. On a square sheet of handmade paper, the artist chose to differentiate the forms from the background. On the background of the painting, she created transparency and texture by using overlaid pieces of gauze. In contrast, the lines of the flowers have been painted thick, solid, and opaque with a flat brush. She has used a cool range of blues and white colors.

For this painting, the artist has chosen a square handmade paper on which she has painted with two different tools: a synthetic flat brush to paint the first opaque layer, and a few pieces of gauze to paint the second transparent layer. The use of paint layers and bright yellow and green colors produces fresh expressive results.

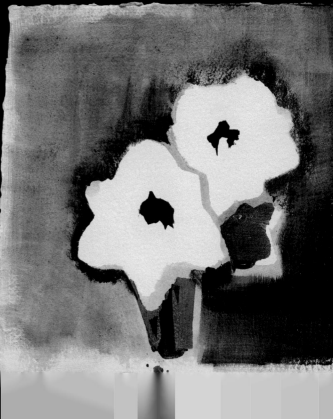

This is perhaps the most atmospheric of all the paintings. This time the flowers have been left almost empty and the background was painted with a wet sponge. The paint was applied wet on wet, spreading and forming gradations to create an attractive effect of rose, violet, and mauve tones.

The artist has produced the most delicate piece of the gallery on a rectangular sheet of handmade paper. Only the flowers have been painted, while very carefully and precisely distinguishing them from each other. She has used very different tools, synthetic brushes and a sponge. The colors are warm pinks, reds, and maroons.

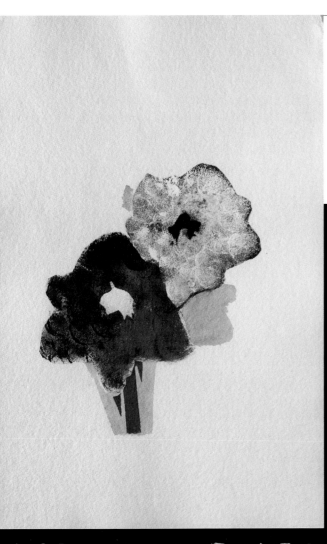

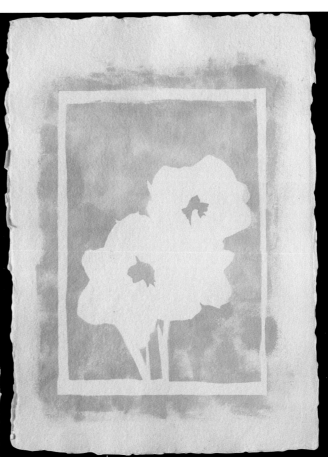

In this work, also on rectangular handmade paper, the artist has used a single stencil to paint the background turquoise with a paint roller. Here, the empty space contains the shape of the flowers. The direct and attractive result is obviously influenced by Pop Art.

Subtlety and simplicity are the watchwords of this painting. The mauve and white tones are very similar to the color of the paper. The stencils protected nearly the entire piece of paper and only the outline and the insides of the flowers have been painted sparingly with a wet on wet approach.

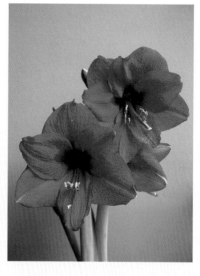

Another point of view In the previous paintings the composition was based on a single and central motif. Here, to produce a different point of view, Gemma Guasch has painted the flowers using repetition. To achieve this, she has changed the composition of the model to make it more dynamic and to create different unlimited rhythms. For the first one, she has superimposed the stencils on a sheet of cardboard. For the second, she has repeated the motif symmetrically and diagonally on handmade paper. Both compositions have been painted with cool colors, blues and whites. By repeating and overlapping the different stencils, the paintings acquire a spontaneous and creative feeling.

Reserves

Creative Techniques **Acrylics**

Another model This time, the model is a simple still life with a clear horizontal line that perfectly describes the different elements placed on a shelf or table. The artist has used handmade paper and different applicators: a synthetic narrow flat brush, a few gauze pieces, and a paint roller. First, she painted the background with the roller, after protecting the elements of the still life, and has made a small rectangle that resembles a window. Then each element was painted individually, using different reserves and painting them separately. Finally, the artist has painted the background with texture and transparency using the gauze. The chosen colors, which are warm and luminous, convey the feelings of immediacy and life.

13 New Colors

Creative Approach

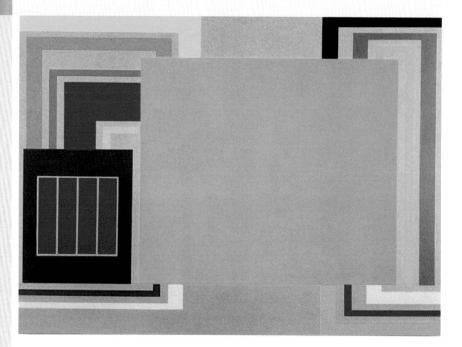

Peter Halley, *Powder*, 1995. Private Collection.

One painter who represents the avant-garde spirit of the acrylics industry very well is the American Peter Halley (born in 1953), a painter, professor, and prestigious theorist. He is considered to be the founder of the Neo-Geo movement, or Neo-Geometric Conceptualism, a branch of abstract art in the last decade of the 20th century. Unlike other abstract painters before him, Halley does not conceive of abstract forms as being independent from reality, but from a Post Modern point of view, as a sign of variable referents, rejecting any idealism. His paintings are social landscapes: connections, circuits, masses, walls, jails, highways, graphics, and diagrams. As he himself describes "…the shining neon that announces trips, sports, debates. Conduits of all kinds flowing in and out giving us conversation, air conditioning, light, water, music." Technically, Halley uses very diverse acrylic paints: traditional acrylics, metallic colors, phosphorescent paint, fluorescents, Day-Glo, Roll-a-tex, and other acrylic-based substances that are used more in industry than the art world. He spreads the paint on the canvas with rollers to create the effect of the cold textures of doors and walls. His work *Powder* contains all these acrylic materials and even a phosphorescent tone or two, which he considers "today's version of cheap mysticism."

Painting with Fluorescent, Iridescent, and Interference Acrylics

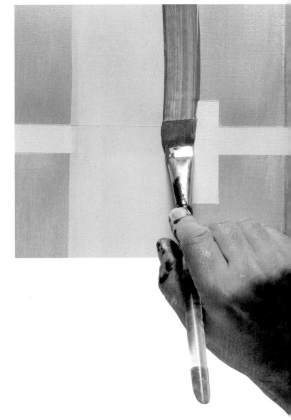

Following the style of Peter Halley, the artist for this creative approach, Josep Asunción, develops a series of geometric abstractions with a clear visual reference. Basing his work on some buildings and urban elements in the city of Boston, he creates formal relationships between planes and connections, like the façades and roads. The goal is experimentation with untraditional acrylics: fluorescent, iridescent, and interference paints, all developed recently. Here he works on paper with a canvas texture with synthetic brushes and wide spatulas.

"These days crossing the line is just becoming imitation, but in the end the vital moment of the transgression turns into stupefying narcotic of fascination. ... The key moment of this transformation took place when Andy Warhol silkscreened the electric chair in phosphorescent colors."

Peter Halley, 1995, *New Observations*.

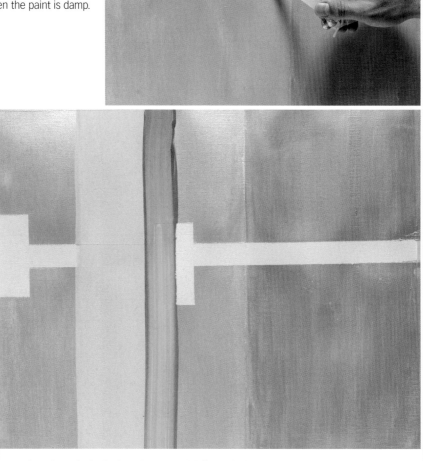

1. Asunción prepares a base of colors that already contains the basic geometric composition of the work of art. He made it using masking tape as a reserve. He focuses on a traffic light as a structural guide, and paints a first layer over the reserves with silver and gold iridescent paints.

2. He removes the masking tape leaving the unpainted white paper. He works slowly and carefully, so he does not tear the paper fibers. He did not wait for the paint to dry because it is easier to remove the tape when the paint is damp.

3. When the paint is dry he paints two pink lines. The lighter and wider stripe is a pearly iridescent white mixed with a little fluorescent red, and the darker and narrower line is pure phosphorescent red. Each brush line is a single brush stroke applied without heavy pressure or repetition.

4. Two more transparent applications are added at the right of the painting. First, a wide vertical band of pale yellow, made by mixing iridescent gold paint with iridescent pearl white and gel medium to make it more transparent. Over this yellowish band he painted horizontal brush strokes of iridescent steel gray, and then he scraped it with a spatula to make light and darker areas of varying opacity.

5. He continues, now with metallic steel gray, scraping it with the spatula to create a wide line with rough edges. Finally, he uses fluorescent red to apply the lights of the traffic light as focal points of color and visual tension.

The artist has continued to create variations on the theme, based on the principles of Peter Halley's Neo-Geo style. Key elements are the composition, the textures of the colors, and the effects of the strange chromatic vibrations caused by such atypical ranges of color.

Only three colors are used in this Minimalist work: fluorescent red, interference green, and iridescent steel gray. The distribution is very simple, like the synthesis of a cityscape. Asunción worked with paints with different amounts of fluidity to create different textural effects and to avoid making the paintings too cold.

In this composition he used warm iridescent colors (gold, copper, and bronze), as well as pure white and pearl white mixed with turquoise blue. The poetic effect of the work is caused by the dialogue between the different textures of the paint when fluid strokes combine with thick heavy ones.

Dragged streaks of gold, silver, and mother of pearl tones lightly tinted with fluorescent red and pure white were applied over a base composition of two large planes of iridescent pearl white and red copper. To complete the composition the lights of the

This painting was based on a horizontal division in two colors, copper and steel, with a white reserve made with masking tape. The first brush strokes were gradated to create a more subtle and even effect. Several brush strokes with blue, yellow, and red fluorescent colors along with iridescent silver, were applied over this base.

This painting is more dynamic than the others in this gallery because of its more organic and fluid looking brush strokes in the upper area. This variation opens the door to new possibilities that the artist can develop as a new focus in the project. The colors used are gold and silver on the base, and fluorescent red, steel, and white on the later layers.

The most subtle work in this gallery was made with very pale white tones lightly tinted with fluorescent red, interference blue, and steel gray, very diluted with acrylic medium. The original base was very light and glossy, silver mixed with iridescent pearl white.

Creative Techniques **Acrylics**

New Colors

13 Window

New
Approaches

Another point of view Fascinated by the strange and expressive new colors, Josep Asunción continued to experiment with another very different abstract approach, gestural abstraction. While the previous geometric abstraction organized its elements in "cold" formal planes, lines, and points, gestural abstraction is based on a personal calligraphy that can be very expressive. The strokes become more intimate and charged with energy, and the color becomes more vital.

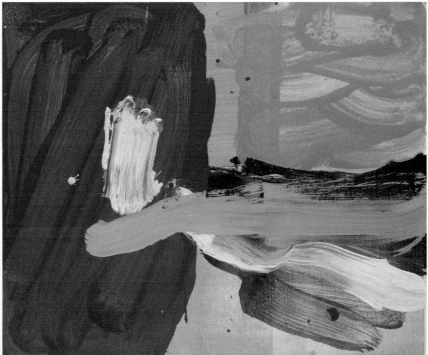

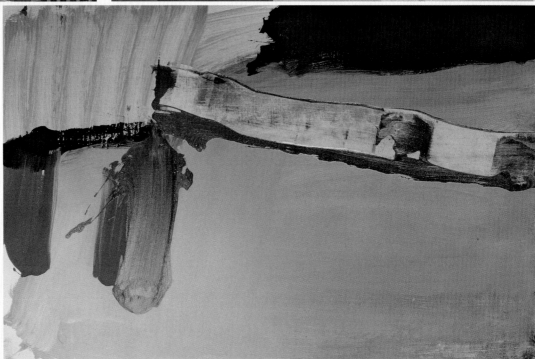

Another model Continuing with the same flat geometric approach from before, the artist now experiments with a compositional scheme based on diagonal lines instead of horizontal ones. The photograph of some windsurfing sails is an ideal model for looking at how the same style can become visually unstable and dynamic when diagonals are substituted for horizontals. Despite the coldness of the geometry, a new element appears in the picture: movement, which is created by the rhythm of the diagonal lines.

14 Mixed Media
Creative Approach

Sigmar Polke,
*Magnetische
Landschaft*, 1982.
Private collection,
Dusseldorf,
Germany.

In 1953, at only twelve years old, Sigmar Polke (born in 1941) escaped from Communist Eastern Europe and settled in Dusseldorf. There he studied in the famous art academy where Joseph Beuys taught. He established a close friendship with his classmate Gerard Richter, and in 1963 the two founded "Capitalist Realism," a European version of American Pop. With this name, they established a connection with the art that supported the Soviet Union: Socialist Realism. In their work they satirized the supposed capitalists, who they thought were bound by a society of consumerism. In the 1960s and 1970s Polke began to manipulate banal images extracted from the media and mass culture, of kitsch and of publicity, and became interested in photography. From 1980, he experimented with materials and chemical products, mixing traditional pigments with resins, lacquers, solvents, and toxic substances, allowing them to react spontaneously. He was always a radical and unorthodox risk-taking painter who has enthusiastically absorbed everything that could expand his horizons. Instead of canvases, he uses commercial fabric for his artwork, as seen in the *Magnetische Landschaft*, a painting from the series of representational landscapes made with printed fabric, ferrous mica, and acrylic. In these he questioned the academic idea of the landscape, interacted with the viewer, and introduced little-used materials.

14

Combining Acrylics with Other Media

Because of its versatility, acrylics are often combined with various media. Since its development, acrylic paint has possessed a bold and experimental spirit that has earned it the nickname "all terrain," because it is flexible, it is moldable, and it can handle a lot without wavering. In this same spirit, in this landscape Gemma Guasch sets out to mix the acrylic paint with dry media, pastels, crayons, and wax; wet media like India ink and liquid watercolors; and oil media in the form of enamels. She uses a canvas board and applicators like brushes and sticks of color. The chromatic range is colorful and energetic.

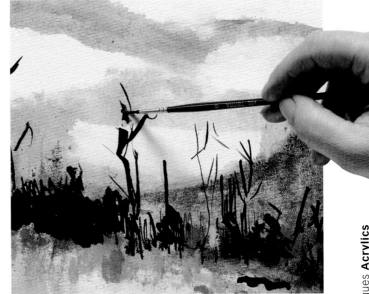

We can't just count on good pictures being painted some day. We have to take charge of it ourselves.

Sigmar Polke

Creative Techniques **Acrylics**

129

Step-by-Step
Creation

1. Gemma sketches the compositional lines that give structure to the landscape with the acrylic paint, which is diluted to reduce the intensity of the color. It is applied with a round, fine, soft-haired brush. Then, she marks the lines of the clouds and a little bit of the grass in the meadow drawing directly with sticks of water-soluble wax.

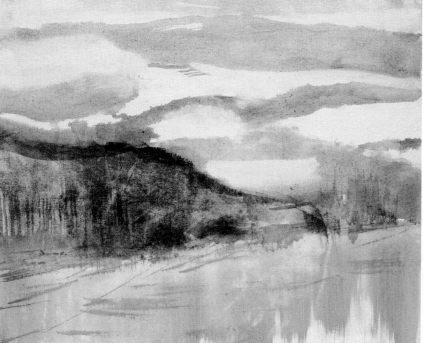

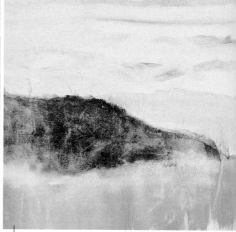

2. She passes a synthetic-hair brush, moistened with only water, across the lines of the clouds. The watercolor sticks dissolve on contact with the water creating lighter strokes. She uses a flat synthetic-hair brush to paint the mountain with vivid tones of fluid acrylic paint and a sponge to paint the meadow.

3. She lets it dry before continuing to paint. This time, she chooses blue and green artist's inks to paint the grass in the meadow and part of the sky. She uses a round, fine, soft-haired brush to do this. The ink is transparent and allows us to see the previous strokes. Finally, she applies white acrylic paint to give the clouds density.

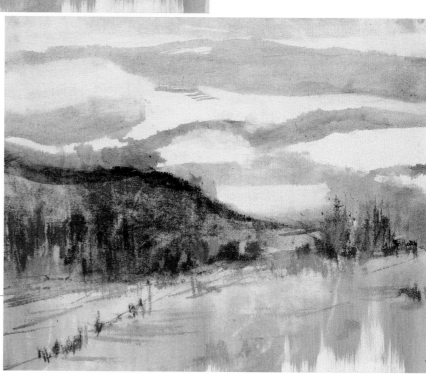

4. After the inks have dried, she uses the watercolor wax sticks to draw small lines that define the grass in the meadow. Guasch uses vivid and varied colors: blue, green, pink, magenta, and yellow.

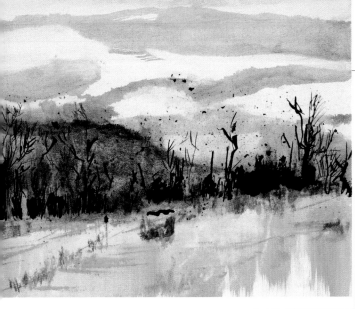

5. Then, she paints the trees with black India ink and a soft brush; she visually separates the mountain and the meadow and adds depth to the space.

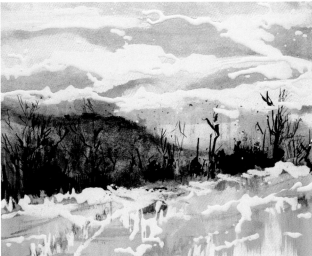

6. When this dries, she begins to apply an oil medium: white enamel paint. To do this she uses a hog bristle brush, letting the liquid spread from the meadow to the sky. Remember that the enamel (oil medium) is diluted with essence of turpentine.

7. Finally, to differentiate the contrast of the enamel in the sky and the meadow, she dilutes the enamel on the meadow with turpentine. By thinning the medium, we create an expressive glaze that allows the previous brush strokes to show through.

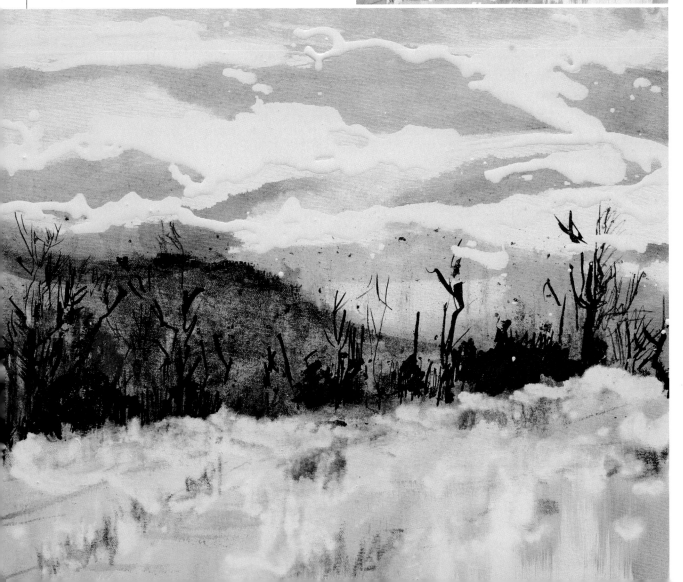

Creative Techniques **Acrylics**

14 Gallery

Other Approaches

Gemma Guasch has put together this gallery following the same line of experimentation and thinking about mixing acrylic paint with different media. She has varied the types of canvas and the media to complete this landscape in new and surprising ways.

This picture has been painted on a board with a frame. The acrylic paint has been mixed with oils, varnish, and sticks of chalk. Hog bristle brushes of different sizes were used. The final result is solid, dense, and heavy. The lines drawn with the different colored sticks of chalk emphasize the gracefulness of the grass in the meadow.

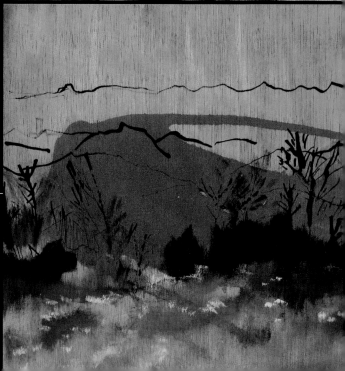

This expressive and less realistic landscape has been painted on a board with a frame. The acrylic paint was mixed with black India ink and oil paint. Hog bristle brushes of different thicknesses, reed pens, and sponges were used. The mountains and the sky were suggested with light India ink lines. On the other hand, in the meadow the paint was applied with a dry brush, which created a beautiful atmospheric feeling.

A heavy paper was used to create this piece. The acrylic paint has been mixed with India ink, artist's inks, chalks, and pastels. Dry media was applied when the paint had dried completely. It stands out because it is superimposed over the other media.

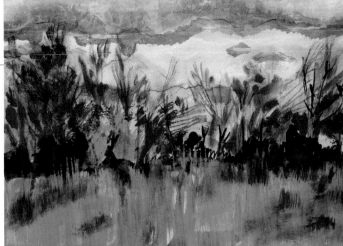

This less colorful landscape was created on a slab of wood painted red. The artist used diverse media: acrylic paint, silver enamel, and China ink, applied with hog bristle brushes of different sizes. When mixed, these media reacted in different ways, causing expressive blurring and gradations that contrast with some of the heavier lines.

In the next landscape, painted on a canvas board, water-soluble media have been mixed with oil-based media. The oil media, gold enamel, and oil paints are oily and repel the wet media: acrylic paint and artist's inks. Random bleeding has been created in some lines.

Creative Techniques **Acrylics**

14 Window

New Approaches

Another point of view To create a more radical vision of the landscape, Gemma Guasch has decided to approach it as an abstract. She has chosen a large handmade paper and has combined different media: artist's ink, gold enamel, black India ink, and acrylic paint. Instead of using brushes, she poured the paint, previously diluted in containers, and moved the paper. These actions have configured the landscape in a new way. The shapes that she created are totally free and loose.

Another model The still life has been used by painters from all eras for experimentation and research. For this reason, Gemma Guasch decided that the second model for this project should be a still life full of transparent glass containers. This picture was painted on a cotton canvas support with acrylic paint mixed with varnishes, asphaltum, enamels, oil paint, and India ink. The final result is dynamic in its shapes and varied, lively lines and is restrained in its colors: white, black, and silver on a red and tan background.

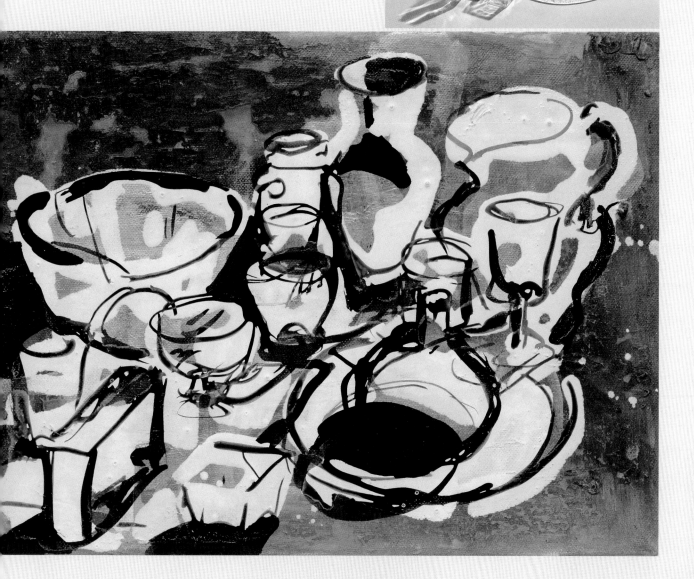

Form

What is form and how is it perceived?

Form, on one hand, is the external appearance of objects and, on the other, the mental model that helps us identify them. We recognize forms because of their structure, which is determined by the limits of the object or by its interior skeleton. In the act of perception, we relate that structure to the previously accumulated experiences in our memory. Perceptively, we do not need the complete information about a form to recognize it (in figure A we recognize a square by only seeing its

BASIC CONCEPTS

Abstraction

An abstraction is an image in which we cannot identify forms known in reality. This does not mean that reality does not contain abstract forms; you can look at an old worn door, the structure of a building, or through a microscope to be sure of that.

An abstraction.

Chiaroscuro

We can visually perceive forms only because light falls on them. But the light creates shadows, and they are as important as the light, as are all the values in between. Chiaroscuro is what we call the play of light and shadow.

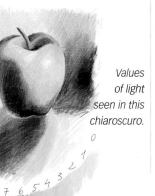

Values of light seen in this chiaroscuro.

Outlines

Outlines do not exist in reality, they are a linear interpretation that an artist makes to mark the edges of forms in relation to other forms or in respect to the background.

Outlines.

Blur

This is the act upon a form in drawing or painting of erasing, deforming, overlapping details, and creating ambiguities to lose all formal correctness. The objective is to place expression above representation.

Blurred figure.

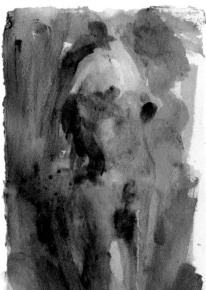

Skeleton

The form skeleton is the internal structure that all objects have. Sometimes this skeleton is real, as in the human body; other times it refers to a geometric figure that can contain the form, like a sphere, a cube, or a cylinder.

Form skeleton.

Mass

This is the space that a form occupies in a painting. The mass implies a visual weight, and that weight is determined by its size and the density of its color. A large mass of light or diluted color weighs less than a smaller mass of dark or dense color.

Mass.

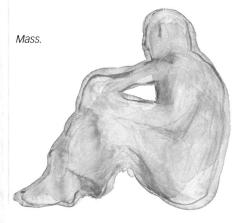

corners). Furthermore, we can direct the perception since it is a mental process and not a mere act of reflection (in B we see the arrows pointing up or down according to the way we want).

A

B

Modeling

This is the treatment applied to the form to create a sense of volume. Lines are added or subtracted, and the intensity of the tones and amount of dilution is controlled.

Modeling.

Layout

The first steps in a watercolor are very important because they distribute the elements that make up the image. A form is laid out from the inside out, that is, from the essence to the details. In this sense, a method of laying out is blocking, or putting forms in "boxes" or basic shapes like cylinders, cones, spheres, cubes, and ellipses. A less academic method consists of applying a series of intuitive lines, each based on the previous one.

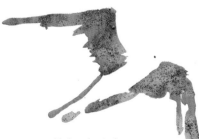

Layout with brush strokes.

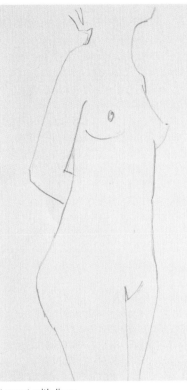

Layout with lines.

Silhouette

The silhouette is defined by the edges of the mass in space. It has no details, but it suggests the form if it is in a good position.

Silhouette.

Synthesis

Synthesizing is reducing the information to a minimum, leaving only what is essential for recognizing the form. You can synthesize with lines by reducing the outline to the minimum, or with color by working with the silhouette or chiaroscuro based on values of light.

Synthesis with lines.

Volume

This is the three-dimensional aspect of the form. This term refers to the amount of visual presence of the image. An image "has volume" when it contains contrasts and the forms stand out.

Volume.

Color

What is color and how do we perceive it?

Color is a phenomenon of perception. Things are not a determined color, they are just "perceived" as being that color in certain conditions of light. A sheet of paper is perceived as white under sunlight, blue gray in the shade, and yellow under the light of a lamp.

Isaac Newton (1643–1727) discovered that light breaks up into the chromatic spectrum when it passes through a transparent prism. This is the same

BASIC CONCEPTS

Color Wheel

If we were to connect the first color and the last color of the color spectrum (magenta and violet) we would make a circle. In this circle are three pure colors, which cannot be created by mixing others. These are the primary colors, magenta, lemon yellow, and cyan blue. Mixing them with each other will create the secondary colors, orange, green, and violet. And mixing the secondary colors creates the tertiary colors, blue green, yellow orange, and so on.

Chromatic Chiaroscuro

There are two kinds of chiaroscuro with color: the value approach and the colorist. In the value approach the color goes from its lightest tone, mixed with white, to the darkest, mixed with black or its complement. However, black and mixed complementary colors are never part of a colorist chiaroscuro because it uses pure colors. In this approach a colorist painter works with paint that is naturally bright or dark.

Complementary Colors

Two colors are complementary when they are located opposite each other on the color wheel.

Adjacent Colors

Two colors are adjacent when they are near each other on the color wheel.

Warm Colors

The colors that range from violet to yellow green on the color wheel are considered warm. Visually they suggest a sense of warmth. Black is neutral but tends toward warmth.

Warm colors.

Uniform Colors

In an acrylic, when the colors in one area are very similar in tone, value, or both, we say that they are uniform.

Cool Colors

These are the colors ranging from blue violet to green on the color wheel. Visually they suggest a sense of coolness. White is neutral but tends toward coolness.

Cool colors.

Neutral Colors

A color is neutral when it has been mixed with its complementary color. It looks gray and dark because it has lost its vividness. They are also called "broken" colors. Neutralizing a color is the natural way of darkening it.

The color wheel.

Pastel Colors

Colors with a pastel tone contain white and are lighter than usual.

Pastel colors.

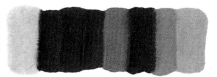

Neutral colors.

phenomenon as when sunlight passes through raindrops and causes a rainbow to appear, its colors are the chromatic spectrum. When light falls on an object, it absorbs all the colors of the spectrum except one, which is the one that reflects back to the viewer. This is the color of the object in that kind of light.

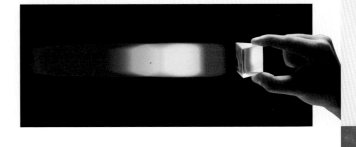

Saturated Colors

A saturated color contains none of its complementary color, and no white or black. This means it is absolutely pure, with all of its natural energy.

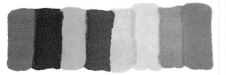

Saturated colors.

Contrast

There are three kinds of color contrast. *Tonal contrast* exists between different colors from the color wheel, the maximum contrast is between complementary colors. *Contrast in light* is between light and dark colors. *Contrast in saturation* is between a saturated color and a neutral color. For example, an extreme contrast would be created between a pure yellow and a dark, grayish violet, or between maroon and a bright green.

Contrasting complementary colors.

Range

This is the name for the group of colors used in a work of art. It is sometimes called harmony because it refers to how the colors interact with each other. For example, a monochromatic range is based on a single color, and a harmonic trio contains the colors that are located at each point of an equilateral triangle on the color wheel.

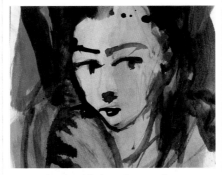

Monochromatic range.

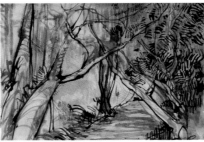

Harmonic trio with the primary colors.

New Colors

Many colors have been created for industrial applications, but today they have also been incorporated into artistic language. Among them are iridescent colors (which create a play of brightness and reflections), metallic, pearlescent, phosphorescent (which because of their chemical composition refract more light than normal colors, especially in the dark), and interference colors, which act as slightly colored transparent lacquers that alter the underlying color.

Tone

This refers to the location of a color on the color wheel, not its brightness or purity. It is also used in the same sense as the word "shade." Thus, a color can have a bluish, orange, or bright red tone, or shade.

Value

This is the amount of light a color has. In the color wheel the brightest color is yellow and the darkest is violet. But each color can become lighter or darker as it approaches white or black.

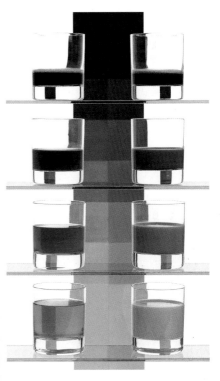

If you dilute coffee with water you lighten its value but maintain its tone, while if you dilute it in milk it becomes lighter and more pastel. The same happens with paint, if you lighten a color by diluting it as opposed to adding white to it.

Color Vibration

This is a very common concept that refers to the elements of color contrast in a watercolor. This vibration may be subtle or very intense, depending on the amount of contrast.

Creative Techniques **Acrylics**

Space

What is space and how is it perceived?

We perceive visual space because of two factors, light and perspective. On one side, light makes it possible to perceive volume and depth. On the other, perspective helps us establish relationships of distance. Things that are near seem to be larger, clearer, and have more contrasting light. Let's look at some perceptive phenomena related to space: gradations (A) cause a visual sense of depth; in general the darkness suggests more distance than the light. Perspective mainly works with the

BASIC CONCEPTS

Atmosphere

In a painting the atmosphere transmits a sense of airy density. When a painting has atmosphere, it seems the brush stroke fills the air with particles and makes it dense and tactile, like steam, fog, or dust. An atmospheric painting often uses glazing and dry brush techniques to reduce the perception of clarity.

Framing a landscape.

Atmosphere.

Composition

This refers to the distribution of the elements in a painting. It follows the artist's expressive intention and establishes a visual path: central elements that capture the attention, then secondary and marginal aspects. Compositional schemes often are laid out to ensure visual balance or equilibrium.

Framing

This is the selection of the scene. Included in framing are the format (square, landscape, portrait), proximity (we can move closer or farther away from the scene), and point of view (lateral, frontal, angled, etc.).

Compositional Scheme

This is the synthesis of a composition, the general scheme of the distribution of the elements. The most common compositional schemes are the centralized composition, which centers the subject in the painting in a very balanced and static manner (1); the more dynamic diagonal composition (2); and the radial composition (3), a result of perspective.

1 Central composition.

diminishing size of objects (B). Overlapping (C) consists of defining the planes by partially covering the painted objects, the closest one hides parts of the others. Finally, the manipulation of focus and blurring can also create distance (D), an approach learned from photography.

2 Diagonal composition.

3

Radial composition.

Figure and Ground: This is the relationship established between the figure and the background. It implies decisions regarding whether they should be visually separated or not. The background can be considered a fundamental part of the work, not just the physical support of the theme. To successfully integrate the figure and the background, you must not create too much contrast between them.

Format: Format refers to the shape of the support, although this term is also used to designate the sizes of works of art (small format, large format, etc.). The most common formats are those established by the metric DIN standards, especially DIN A4 (8.3 x 11.7 inches), and DIN A3 (11.7 x 16.5 inches), as well as standard measurement formats: 19.7 x 27.8 inches and 27.8 x 39.4 inches.

Point of View: This is the position of the artist in relation to the subject he or she is painting.

Rhythm: This is the unity seen in the change and variations. Rhythm creates a sense of movement in the work. It is produced by repetition or by altering forms according to a cadence. Varying the intensity or the position of the objects will cause visual motion and guide the viewer's eye. With rhythm the negative space has as much value as positive space, just as in music the silences are as important as the sounds.

Rhythmic repetition and variation of size.

Projected Shadows: Projected shadows are the silhouettes of objects cast on the plane that the objects sit on, or cast on other objects nearby. They are caused by the position and intensity of the light projected on the objects. The use of projected shadows creates a sense of space in the painting.

Projected shadows.

Line

What is line and how is it perceived?

The line is the physical dimension of the painting. Form, color, and composition are elements that refer to the "what" of the painted image, while the line refers to "how" the image was physically created. It is related to the materials and the intentions behind the construction of the image, basically referring to two aspects of the work: the texture and the gesture. In the former, material factors come into play: the support, the material, and the applicators; in the latter, procedural factors

BASIC CONCEPTS

Gradations

Gradations are the gradual passage of one color to another, or of one shade of gray to another. They can be very blended, or they can leave each state of the color totally differentiated from the others, in the form of flat or textured areas of color.

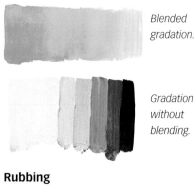

Blended gradation.

Gradation without blending.

Rubbing

This is done to create a tone, lightly rubbing and leaving no trace of the original line. A rubbed surface generally creates a soft and atmospheric effect. In acrylic we create such effects by working quickly in damp paint, or even in washes.

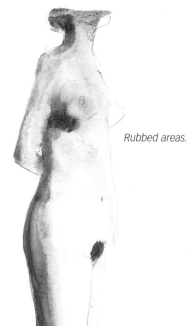

Rubbed areas.

Gesture: Gestures are created by modulating lines. They are related to the movements of the hand, and by extension the arm and the position of the body. Understanding the expressive possibilities of gestural painting is something that today is perfectly normal, but this is recent and owed to the rich influence of the long tradition that oriental painting has in this approach. Western influences from the 20th century include the Abstract Expressionism from North America and the work of Picasso.

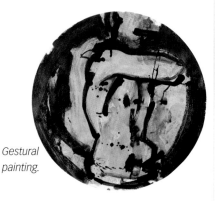

Gestural painting.

Intensity

This is related to the amount of acrylic paint held in the applicator. A brush stroke is intense when it contains more pigment than water, or when the paint has volume or a textural filler.

Washing

Washing means removing the paint that was previously applied and that is in a more or less advanced state of drying. To wash a painting or a part of it, a diluent is applied directly or with a rag or sponge and then it is dried with a rag. Controlling the flow of water and the pressure while washing and drying will create an atmosphere of varying density.

Juxtaposed Areas of Color

Using juxtaposed and overlapping colors you can create transparent effects. When one transparent area of color covers another, visual blending occurs. This is called glazing, one of the most widely used painting techniques.

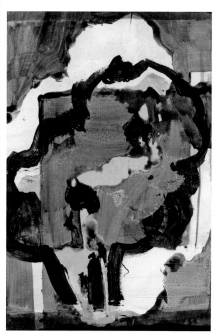

Juxtaposed areas of color.

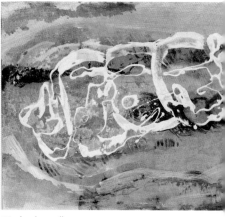

Washed acrylic.

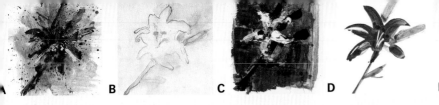

<div style="text-align:center">A B C D E F</div>

like the speed, intensity, and modulation of the application are important. Using the same model you will express yourself differently using quick wet brush strokes with spattering (A), a slow stroke with very little paint left after washing (B), a spatula with a lot of paint (C), slow and concise strokes of fluid paint with a small brush (D), agile brush strokes that deposit and absorb the paint to make atmospheric areas of color (E), and fine and controlled scratched lines (F).

Modulation.

Modulation

This refers to the form of the stroke, which is determined by the movements of the hand. You can paint strokes that are sinuous, trembling, angled, flat, relaxed, and tangled, among others.

Relief paste texture with sgraffiti.

Texture

This is the tactile dimension of a painting. It can be a visual texture created with hatching, brushes, splashing, transfers, dripping, mediums, salt, alcohol, among others. The textural dimension of a painting adds expressiveness and communicates a greater sense of reality since it increases the physicality of the image.

Hatching

This refers to the color areas normally created by parallel lines that are often criss-crossed. The screen created by these lines can be dark or light depending on how they are applied, and they will correspond to a specific value in a chiaroscuro. Hatching can also be done with dots, but this is not very common.

Painted hatching.

Glazing

A glaze is a color, localized or widespread, made with paint that is very diluted with water, solvent, or medium. The diluted color is transparent and allows you to see the underlying colors. This is the usual way to apply a glaze, with juxtaposed colors, although they can also be applied and then washed, or blended and gradated while they are still wet. Glazing creates a translucent effect, not only to create atmospheric effects but also to add depth to color or gray tones.

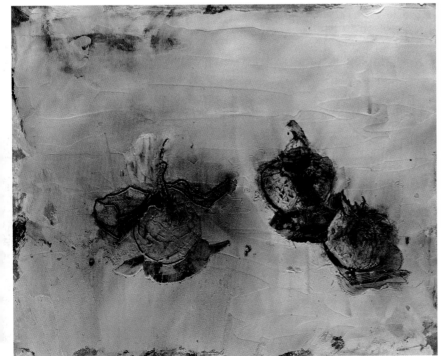

Glazing.

CREATIVE PAINTING

SPACE

FORM
CREATIVE PAINTING SERIES
BARRON'S

COLOR
CREATIVE PAINTING SERIES
BARRON'S

SPACE
CREATIVE PAINTING SERIES
BARRON'S

LINE
CREATIVE PAINTING SERIES
BARRON'S